THE POSTCARD HISTORY SERIES

Annapolis

CAPITAL GATEWAY TO MARYLAND

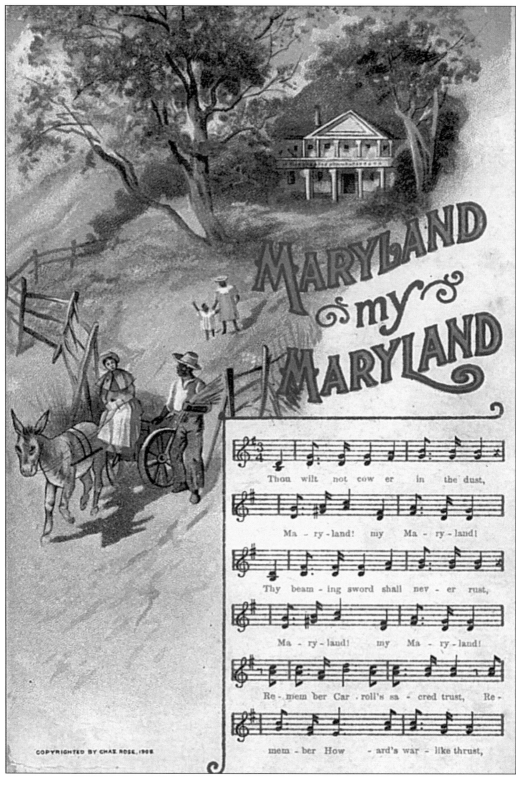

THE POSTCARD HISTORY SERIES

Annapolis

CAPITAL GATEWAY TO MARYLAND

David Brennan

ARCADIA

Published by Arcadia Publishing,
an imprint of Tempus Publishing, Inc.
2 Cumberland Street
Charleston, SC 29401

Printed in Great Britain.

Library of Congress Catalog Card Number: Applied for.

For all general information contact Arcadia Publishing at:
Telephone 843-853-2070
Fax 843-853-0044
E-Mail arcadia@charleston.net

For customer service and orders:
Toll-Free 1-888-313-BOOK

Visit us on the internet at http://www.arcadiaimages.com

CONTENTS

Acknowledgments 6

Introduction 7

1. Affairs of the State 9

2. Historic Buildings 23

3. School for Admirals 41

4. Roadways and Waterways 69

5. Small Town, Maryland 89

6. Gateway to the Eastern Shore 105

ACKNOWLEDGMENTS

They say that life turns on a dime and you never know when a chance meeting or casual word will turn you in a direction you had not considered. So it happens in the creative process. This is an excellent place to say thanks to a few of those people, such as Christine Riley at Arcadia Publishing who planted the germ of the idea; members of the Sunshine Postcard Club of Tampa, Florida for their support and encouragement; Don Hudson of Columbia, Maryland who taught me to be a "player"; Jim Cheevers, curator of the U.S. Naval Academy (USNA) Museum; "friends" Debbie Hager and Charles Goebel at the Easton Historical Society; and Sally Morehead of Annapolis, Maryland who helped solve a "mystery." Special thanks go also to my little buddy, B-J, who seldom left my side during endless hours at the computer. But, most especially to my wife, Sandy, who keeps the dreams alive.

INTRODUCTION

"Maryland, my Maryland" begins the opening refrain of the state anthem of Maryland, also known as "the free state" (a reference to Maryland's refusal to enforce prohibition), "the old line state" (purported to be General Washington's affectionate term for the courageous Maryland volunteers), and most recently (and perhaps most descriptively) "the Chesapeake state." I lived, worked, and played in its countryside, townships, cities, mountains, and beaches most of my adult life, and truly regard it as my Maryland. I still marvel that a state with only a fraction of the land mass of some of its big sisters, such as Texas or Florida or California, has such a wondrous variety of recreational, cultural, and historic attractions. From the rolling hills and mountains of Western Maryland to the relaxing, sandy beaches of Ocean City to the assortment of wildlife and fish in the Chesapeake Bay and tributaries, Maryland offers almost endless distractions, lifestyles, and opportunities to resident and visitor alike.

The focus of this book is the city of Annapolis with reference to some of the cities that grew up around it, extending across the Eastern Shore, which, in the minds of many, exists almost as a separate state. Annapolis is the capital of the state of Maryland, and it, like the state it represents, reflects a proud heritage and a populace that takes enormous pride in its history, culture, tradition, and growth over three and a half centuries.

The city that came to be known as Annapolis actually began as a trading settlement called Providence on the north side of the Severn River. It was born out of many of the same reasons that drove the original settlers out of Europe, mainly oppression and religious intolerance. The Puritan population of Virginia was under severe pressure to conform to the doctrine and beliefs of the Anglican Church. Even though the English Parliament had declared complete freedom of religious expression to the new settlers, Governor Berkeley of Virginia refused to recognize the new guarantees granted to the Independents, as they were also known. In 1649, Cecilius Calvert, the second Lord Baltimore, offered large tracts of land, religious freedom, and trading privileges to the Puritans to entice them to make the move to Providence. Considering that the intractable Virginia governor had already declared them to be in exile, they needed little additional encouragement.

For all his generosity and noble intentions, Lord Baltimore actually had a secondary motive. A Virginian by the name of William Claiborne already had a successful Indian trading post on Kent Island, only a few miles away from Providence. He was attempting to oust Mr. Claiborne through the English courts but felt it would be economically realistic to provide some competition to this upstart Virginia entrepreneur while he waited for the decision of the

mother country to be made. Also, he felt that a strong economic base would help him to maintain his tenuous hold on the Maryland colony.

Consequently, religious issues were soon overshadowed by the exigencies of commerce and the small trading post of Providence grew into a thriving community and tobacco shipping port. One of the community's more prosperous and influential members was a man named Thomas Proctor, who purchased a portion of land on the south side of the Severn River known as Todd's Landing, which exists today as the downtown section of Annapolis. The Providence settlers gradually took up more land on the opposite shore and the community eventually grew to become a major center of shipping and commerce. Today the original settlement of Providence is mostly under water.

The winds of religious turmoil were once again blowing in England and the so-called "Glorious Revolution" of Protestantism in the old country provided the impetus for Maryland Protestants to wrest control from the Catholic reign of the Calverts. Prior to the Maryland Assembly vote in 1694, the capital of Maryland was the town of St. Mary's City in Southern Maryland. The Assembly voted to move the capital to the city, which by this time was called Anne Arundel Towne. The following year it was renamed Annapolis in honor of Princess Anne, sister of Queen Mary. Thus, a tiny settlement of exiled Puritans evolved into the capital of Maryland and a major clipper ship port.

Annapolis is notable and remarkable for many things. Its State House is the oldest capitol building remaining in continuous legislative use. George Washington resigned here as commander-in-chief of the Continental Armies. The Treaty of Paris was ratified here and a new nation was born. Annapolis, in fact, served as the capital of this new nation from November 1783 to August 1784. Four of the signatories of the Declaration of Independence resided here, including Charles Carroll (the only Catholic signator.) Annapolis claims the distinction of being the sailing capital of the world and points to the large number of sailing vessels registered here to support that fact, in addition to its hosting of the world's largest sail (and power) boat shows. The name Annapolis has become almost interchangeable with that of the United States Naval Academy, which has produced many of the most famous heroes and commanders in seafaring history. Although frequently overshadowed by the Naval Academy, an institute of no less importance is St. John's College, nationally prominent as "the school of great books".

While not intended to be a complete and thorough history of the region, my hope and intent is to give the reader a little taste of and appreciation for the richness of the culture, tradition, and heritage of Annapolis and the towns and cities that inevitably evolved throughout this incredible region. Examining the images on the front and messages on the backs of postcards is one fascinating way to take this journey. Through them we learn of the difficulties of travel, the struggles and separations of the war years, and the progress of technology. From the City Docks (where Alex Haley discovered the port of entry for his ancestor, Kunta Kinte) to the homes of historical figures to an obscure little theater group on an often-missed side street near the State House, it is difficult to imagine another city with more historically preserved sites per square mile (thanks in no small part to the exhaustive efforts of the Historic Annapolis Foundation.) Yet, Annapolis is also a city poised to greet the twenty-first century with all the technology, housing, shopping, and entertainment facilities associated with the most progressive of cities. It is my ultimate hope that this book will be not only an interesting tour of the city and its environs, but also a tribute to the planning and concerns of its citizenry and government.

One
AFFAIRS OF THE STATE

The affairs of state are managed capably and well from the State House in Annapolis. It wasn't always this way, of course. The original capital of the state of Maryland was in St. Mary's City in the extreme southern section of Maryland on the St. Mary's River, which empties into the Potomac River on the Virginia border. Politics and special interests are as old as mankind, and in 1694, Francis Nicholson, then governor of the royal colony of Maryland, convinced the Maryland Assembly to move the capital to a port on the Severn River called Anne Arundel Towne, which became Annapolis the following year, paying homage to Queen Mary's sister, Princess Anne. Annapolis, in fact, managed the affairs of the entire country for a nine month period, serving as the new nation's capital from November 26, 1783 to August 13, 1784. A little understood fact is that a Marylander actually served as the very first President of the United States. It wasn't George Washington. His name was John Hanson, and he was the first of seven Presidents elected by Congress to hold the office before George Washington. Under the Articles of Confederation (which didn't work very well) each president served for only one year and Washington was elected only after the new Constitution was written. But, President Hanson left an important mark of leadership and set an excellent example for those who followed. The truth is that, it was due to his efforts that the new republic did not become a monarchy. But, that's a story for further reading. In the meantime, enjoy the images of government offered in this chapter.

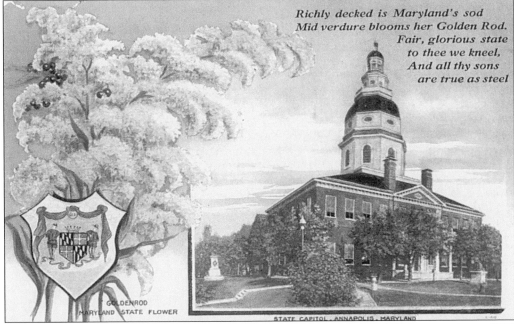

Richly decked is Maryland's sod
Mid verdure blooms her Golden Rod.
Fair, glorious state
to thee we kneel,
And all thy sons
are true as steel

STATE CAPITOL, ANNAPOLIS, MARYLAND. The image on this postcard dates it as prior to 1918 because the Golden Rod is identified as the state flower. In 1918, the Black Eyed Susan replaced Golden Rod as the state flower due to the persistence of a group of women who had become enamored of the plant at the Maryland Agricultural College some 22 years prior.

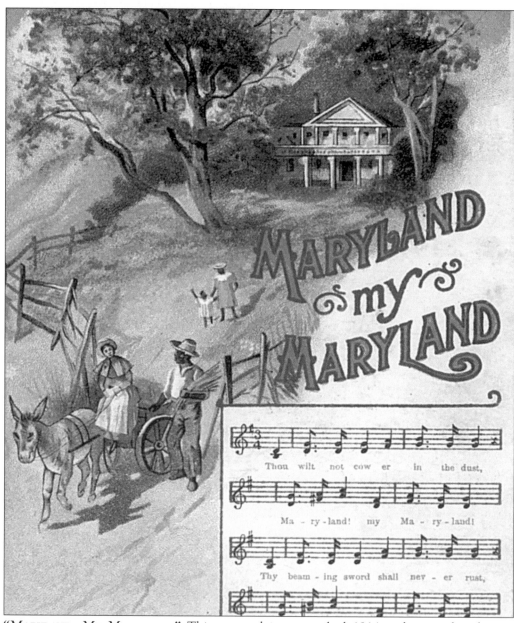

"MARYLAND, MY MARYLAND." This postcard is postmarked 1914 and curiously relates a business proposal for pullets and cockerels, turning down an offer of exchange merchandise and countering with a cash proposal. The subject matter of the image is the state song of Maryland, which is sung to the tune of "O, Tanenbaum." Its author, James Ryder Randall was a native Marylander who had a teaching post in Louisiana at the outbreak of the Civil War. He was shocked to receive the news that Union troops had marched through Baltimore and expressed his outrage through verses such as "The despot's heel is on thy shore, Maryland! His torch is at thy temple door, Maryland!" Mr. Randall was obviously a gentleman not inclined to hide his Confederate sympathies. The song became enormously popular in Maryland and throughout the entire South during the War. And although the conflict had long been over, it was considered such a part of Maryland lore that it was adopted as the state song in 1939.

THE BALTIMORE ORIOLE. There is no doubt that the colors of the Baltimore Oriole and the colors of the Calvert coat of arms are forever linked. What is in dispute is which came first. One version says that George Calvert was so taken with the bird that he chose the colors of his coat of arms based on the bird's plumage. The other version claims the bird was chosen because the colors matched the coat of arms.

Maryland State Bird

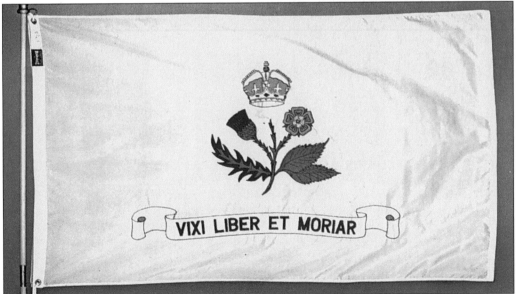

THE OFFICIAL FLAG OF ANNAPOLIS. The emblem on a plain white flag is the personal Royal Badge of Queen Anne, held in such high esteem in the colony that the capital was named after her. This flag was officially presented to the city by the Peggy Stewart Tea Party Chapter of the Daughters of the American Revolution (DAR).

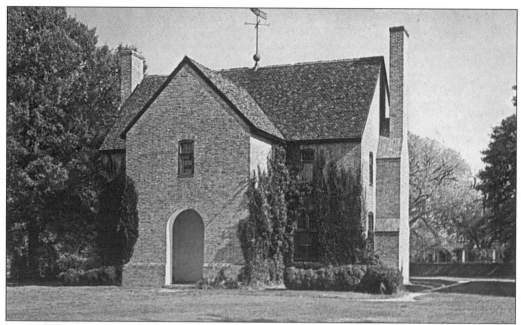

STATE HOUSE OF 1676. This is a reconstruction of the original State House in St. Mary's City, which was home to the Maryland capital from 1676 to 1694. This particular structure was built for the tercentenary celebration in 1934. Although not as grand as its successor in Annapolis, it served the needs of the growing new colony adequately.

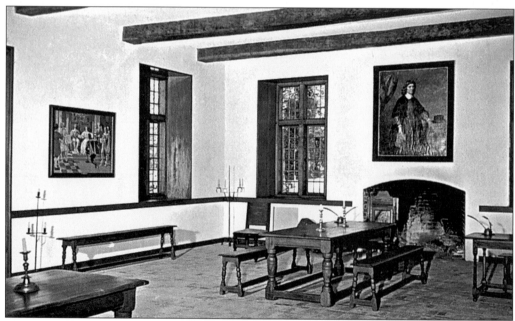

ASSEMBLY ROOM OF OLD STATE HOUSE. This image shows a faithful and painstaking reconstruction of the room where the Provincial Assembly met. The Assembly was composed of delegates from each manor and would be the rough equivalent of what became the House of Delegates. The furniture pieces are the result of many hours of labor by Virginia craftsmen.

State House, Annapolis, Md.

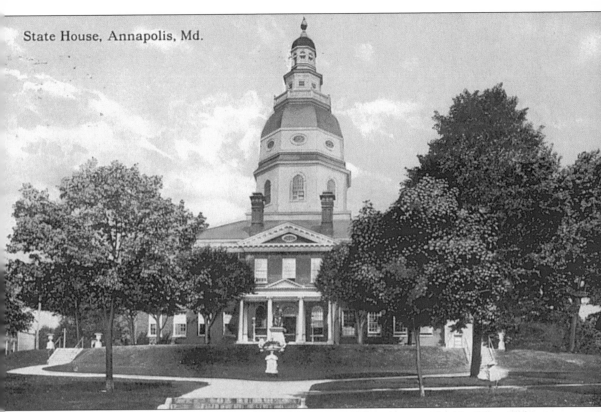

MARYLAND STATE HOUSE AT ANNAPOLIS, MARYLAND. This distinguished building is shown here in a rendering done around 1912 and it remains remarkably unchanged to this day. The major differences are in the landscaping of the grounds and that a faithful reproduction of the "acorn" structure replaced the old one to stave off damage from water seepage. This is actually the third structure to occupy State Circle since Annapolis became Maryland's capital. The first building burned down in 1704. The second became overgrown and dilapidated after only 60 years. In marked contrast to the stiff competition among architects and construction companies today, only one individual submitted plans for the new capitol building. His name was Charles Wallace, and he is credited with the design of the entire building except for the dome. Construction of the present edifice was accomplished between 1772 and 1779. It is the oldest state house in the country still in legislative use.

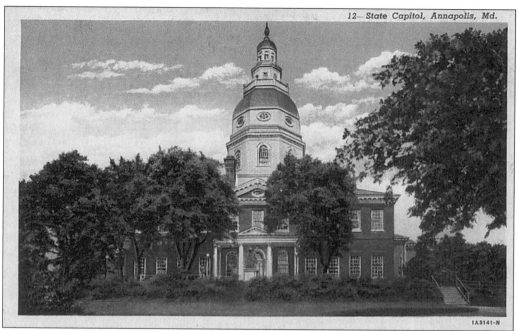

THE STATE HOUSE DOME. The imposing dome of the State House was designed and built in 1788 by Joseph Clark. Perhaps the most remarkable feature of the dome is the fact that the entire structure is held together by wooden pegs that are covered by iron straps actually forged in Annapolis. Additionally, the lightning rod atop the dome is a "Franklin rod" and was made to Benjamin Franklin's exact specifications.

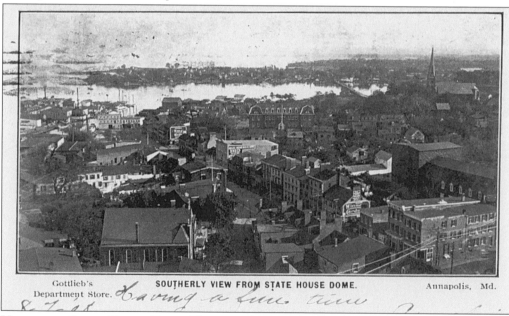

Gottlieb's Department Store. **SOUTHERLY VIEW FROM STATE HOUSE DOME.** Annapolis, Md.

Having a fun time

VIEW FROM STATE HOUSE DOME. This rare photograph taken around 1908 shows a southerly view of Annapolis. Some interesting features of the picture are the old Gottlieb's Department Store on the left, St. Martin's Church in the upper right-hand corner, and painted advertisements covering the entire sides of buildings.

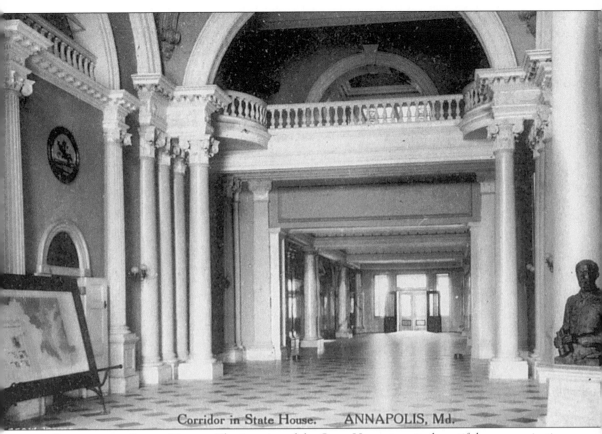

Corridor in State House. ANNAPOLIS, Md.

CORRIDOR IN STATE HOUSE. The interior of the State House is quite beautiful, even majestic, and great care has been taken throughout to preserve much of the feel of old colonial government. In fact, when you walk into the front entrance, you are actually in the Rotunda of the old State House. The photograph on this postcard was taken shortly after a major renovation of the house's interior between 1902 and 1906, which added Italian marble walls and columns. Although not in evidence in this photograph, a broad black line across the lobby divides the two sections. The original section is made of wood and plaster. It's worth noting here that the Annapolis State House is the only state house ever to have seen additional service as the nation's capitol. The many magnificent portraits, statuary, and even a silver service give silent testimony to the rich history contained within the walls of this grand building.

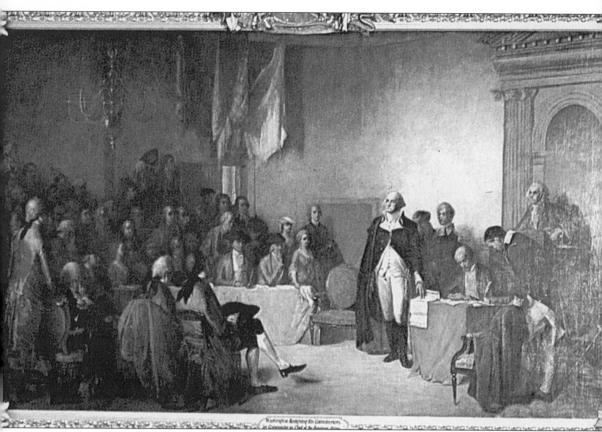

WASHINGTON RESIGNING HIS COMMISSION AS COMMANDER-IN-CHIEF OF THE AMERICAN ARMY. This famous masterpiece, painted by Edwin White in 1859, is perhaps the most valued treasure to grace the walls of the State House. It depicts the event that, possibly more than any other incident in history, determined that the United States would have a representative form of government rather than be ruled by a monarch. It was by the act of formally resigning as head of the Continental Army that Washington, in effect, transferred his military powers back to the civil Congress. After a gala celebration the evening before in which he survived 13 toasts, on December 23, 1783, Washington presented himself humbly before Congress and with a voice filled with emotion announced that he would "surrender into their hands the trust committed to me" to "retire from the greater theater of action" and "take my leave . . ." The entire assembly was silent save for the sobs and tears of spectators and Congressmen alike.

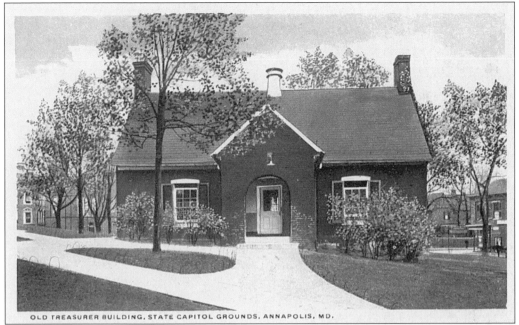

OLD TREASURER BUILDING, STATE CAPITOL GROUNDS, ANNAPOLIS, MD.

THE OLD TREASURY BUILDING. This artist's view of the building (then called the treasurer's building) was rendered around 1910. It is located on State Circle on the grounds of the State House. It was used to house the paper currency that replaced the bulky and inconvenient currency mediums of coins and tobacco. It was really a small fortress; cruciform shaped with barred windows, thick brick walls, and an enormous wooden door.

OLDEST PUBLIC BUILDING. This photograph of the Old Treasury Building shows the deep foyer and heavy wooden door. It is the oldest public building still in existence in the entire state. It was restored to its original condition in 1949, and today it is a treasury of many of the oldest photographs, drawings, and records of the city. It is maintained by the Historic Annapolis Foundation.

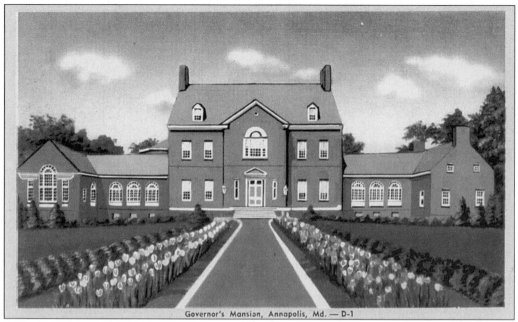

Governor's Mansion, Annapolis, Md. — D-1

GOVERNOR'S MANSION. This artist's painting of the home of Maryland's chief executive was done around 1912. It tries to capture the enormity of the residence with its long entrance walk, spacious grounds, and impeccably manicured landscaping. Despite its immense size, it is meant to convey the impression of a Georgian-style country house.

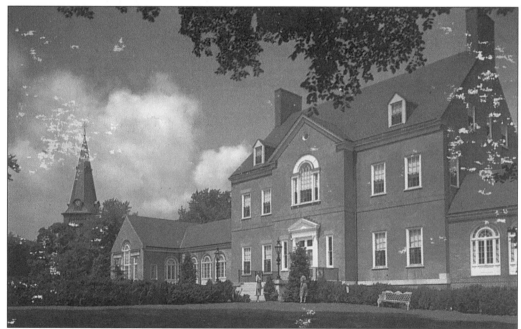

GOVERNMENT HOUSE. This photographic view of the governor's residence conveys a sense of serenity and oneness in its surroundings. This center of the political and social life of Annapolis has been home to the likes of Oden Bowie, Marvin Mandel, Harry Hughes, Spiro Agnew, and William Donald Schaeffer. Its current residents are Parris N. Glendening and his wife, Frances.

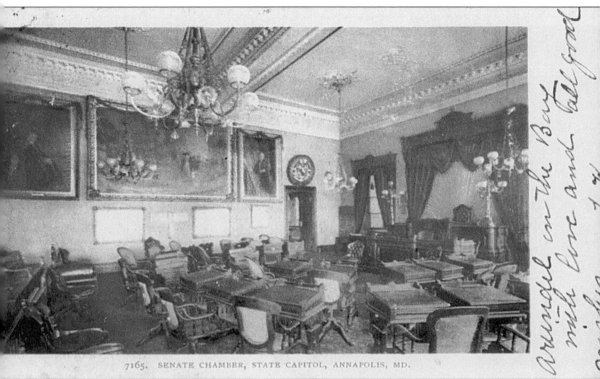

OLD SENATE CHAMBER. This 1904 image of the Senate chamber in the State House shows some of the magnificent paintings, ornate chandeliers, hand-carved furniture, and heavy draperies which are reminiscent of an age that placed a high value on craftsmanship and attention to detail. The center painting may be *Washington, Lafayette, and Tilghman at Yorktown.* It was here that the Continental Congress convened from November 26, 1783 to August 13, 1784 and Annapolis was the capital of the new nation. It was also here that Washington presented himself before Congress to resign his commission after hostilities with England ended. In fact, there is a bronze plaque on the floor of the chamber where the visitor can see the exact spot on which Washington stood when he delivered his emotional farewell speech. Only a few weeks later the Treaty of Paris was ratified and the Revolutionary War was officially ended.

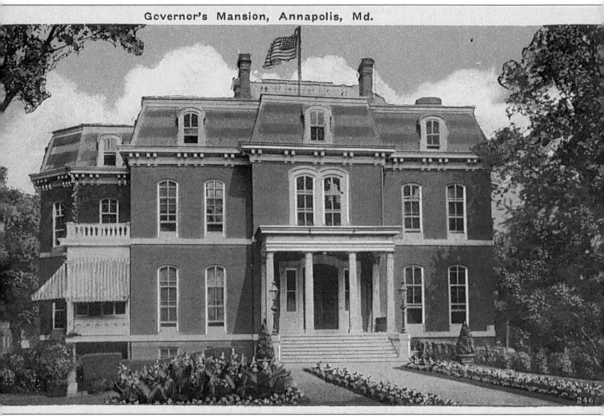

PRIOR INCARNATION. This is the original design of the present Governor's Mansion before wings were added to each side. The mansard-style roof of the original structure was part of the original concept of the dwelling as a Victorian mansion. It was built in 1870 and is composed of both public rooms open to visitors and tourists and spacious private quarters to house the governor and his family. Some distinguished visitors have stayed within its walls, such as Mark Twain, Queen Elizabeth, the Queen Mother, and even the famed boxer Sugar Ray Leonard. The first governor's residence was conceived as early as 1733 but never completed because of disagreements between then Governor Thomas Bladen and the House of Delegates. (Truth be told, the governor was rather a big spender.) The unfinished building was acquired by St. John's College and exists today as McDowell Hall. Besides the addition of wings and a gradual transition to a more Georgian appearance, over the years a new skylight was added and, more recently, a new fountain adorned with state symbols. The interior contains exhibits of important events in Maryland history, portraits of key Marylanders, and an impressive library.

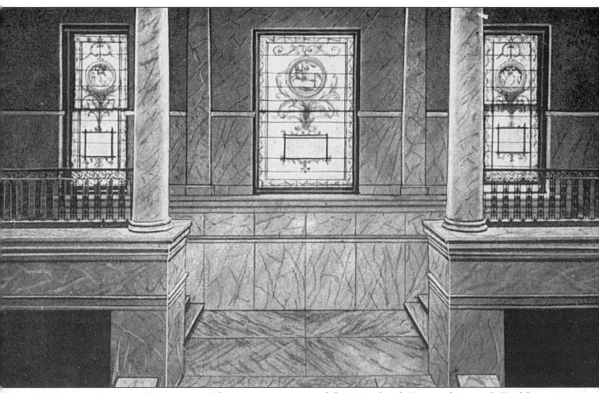

COURT OF APPEALS BUILDING. This interior image of the Maryland Court of Appeals Building dates back to 1908 and shows the marble stair hall and memorial windows. Regrettably, the older structure no longer exists and has been replaced by a modern building. The Court of Appeals has a long history in the state of Maryland. The Constitution of 1776 provided a means by which Marylanders could appeal a decision of a lower court, and this court operated in several other locations of the state before eventually finding a permanent home in Annapolis in 1851. The court is composed of seven judges appointed by the governor with Senate approval. The individual who sent this card was writing to a friend in Richmond and apparently composed a hurried note about seeing a relative in an Annapolis hospital.

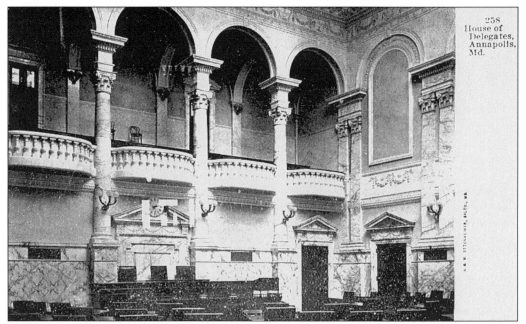

MARYLAND HOUSE OF DELEGATES. The image on this card is a photograph of the then brand new House of Delegates chamber taken in 1905. Although not evident in this black and white photograph, the Italian marble on the walls is colored rust and black, meant to mimic the colors of the state flag. This room and the newer Senate chamber are part of the new annex that was added to the State House.

ANNE ARUNDEL COUNTY COURT HOUSE. This crude attempt to create a photo card of the type popular in the early 1900s is most likely a photograph of another photo created by a private printer. The presence of the automobile in the foreground probably places it more correctly in the mid to late 1940s.

Two
HISTORIC BUILDINGS

One of the more delightful features of Annapolis is the prominence of historic buildings and landmarks. Preserving these precious treasures has been no small feat in the presence of an exploding population and new businesses requiring an expanding infrastructure, taller skyscrapers, coffee bars, and multi-screen movie theaters. But, as the years go by, the people of Annapolis somehow manage to protect these reminders of their important heritage and still keep their city up to date and vital. The downtown section still maintains a colonial flavor despite the fact that you can now buy a Whopper, connect to the internet, and get your VCR fixed. This is due in great measure to the dedicated efforts, much of it voluntary, of two fine organizations. The Maryland Historical Society has done a fine job of increasing awareness in the public mind of the importance of preserving historic landmarks. The Historic Annapolis Foundation frequently gets down in the trenches to raise funds to preserve or even buy a property, thereby rescuing it from the wrecker's ball. (Actually, implosion seems to be the preferred method of destruction and desecration these days.)

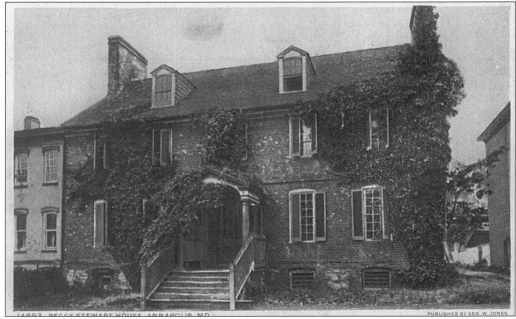

PEGGY STEWART HOUSE. The Peggy Stewart House will forever be the symbol of the Annapolitan version of the Boston Tea Party. Anthony Stewart of Annapolis arrived back in port on his brig, *Peggy Stewart*, complete with a cargo of English tea. He was greeted by a mob enraged over the Stamp Act and was forced to set fire to his own ship. (His other choice was to be hanged at his own front door—good call, Tony.)

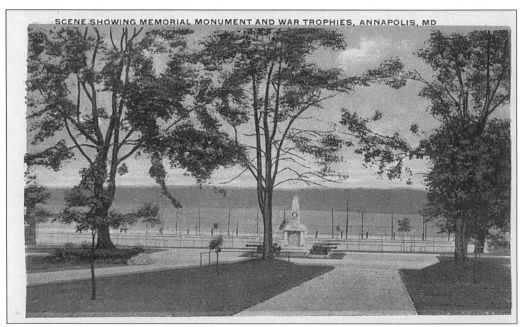

SCENE SHOWING MEMORIAL MONUMENT AND WAR TROPHIES, ANNAPOLIS, MD

MEMORIAL MONUMENT AND WAR TROPHIES. This image shows a relaxing park-like scene on the Severn River where the visitor can stroll and contemplate the sacrifices made by Marylanders during times of conflict. The Annapolis area has several such sites.

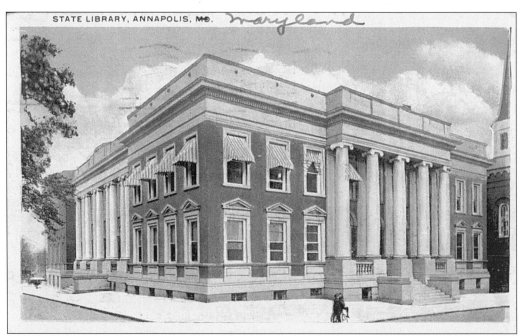

STATE LIBRARY, ANNAPOLIS, MD.

STATE LIBRARY. This image is an artist's view of an imposing building housing an impressive collection of tomes and state reference material. The card is postmarked in May 1941, but was actually published sometime between 1918 and 1935. The message is sent to a friend in Michigan and expresses concern about the effects of a late freeze on the local cherry crop.

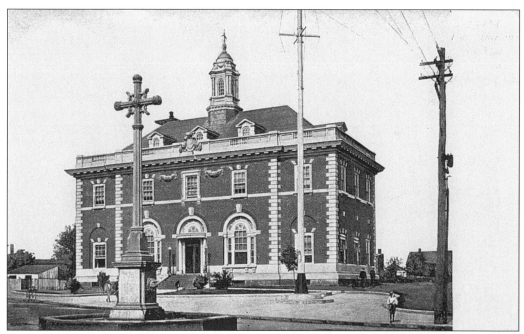

POST OFFICE AND SOUTHGATE MEMORIAL. This striking building complete with dome and widow's walk still stands on Church Circle. In the foreground is the Southgate Memorial Fountain named after the Reverend Southgate, a well-loved Annapolis clergyman. (Southgate Avenue is named after the same gentleman.)

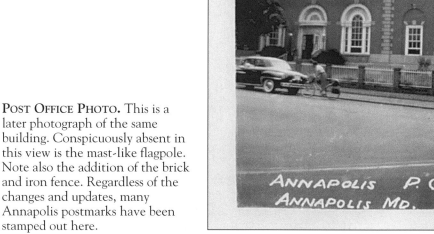

POST OFFICE PHOTO. This is a later photograph of the same building. Conspicuously absent in this view is the mast-like flagpole. Note also the addition of the brick and iron fence. Regardless of the changes and updates, many Annapolis postmarks have been stamped out here.

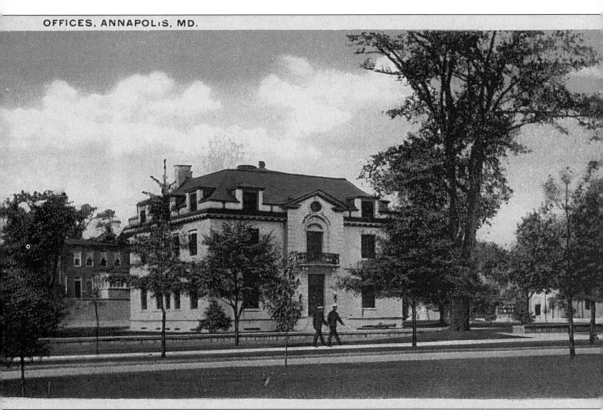

OFFICE BUILDINGS. As the state, city, and populace have grown, so has the need for buildings and office space to accommodate the city's triple duty as a center of government for city, county, and state. Frequently, it's been a trade-off; a present structure of some historic value sacrificed for the cause of yet another office building. But, as this building suggests, the city's planners have always sought to fit the newer buildings in with a minimal amount of disruption to the surroundings and atmosphere befitting the dignity of the capital city.

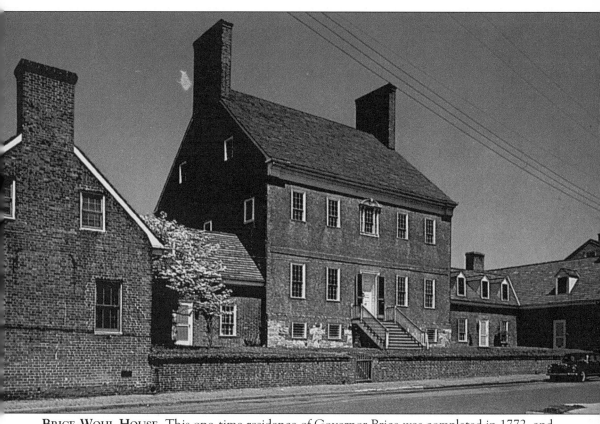

BRICE-WOHL HOUSE. This one-time residence of Governor Brice was completed in 1772, and construction was spread out over a period of 32 years. (I complained that my house took almost 6 months to build.) To this day it is considered by many to be the handsomest example of a Georgian mansion to be built outside England. Many Annapolis structures to come after tried to emulate the style and construction methods of this home which, by today's architectural tastes, could be accused of appearing almost institutional. Nevertheless, it set the standard for years to come in American houses for not only exterior design, but also its sensible and well-laid out room arrangements. The house was later purchased and painstakingly preserved by Mr. and Mrs. Stanley Wohl; hence the shared names.

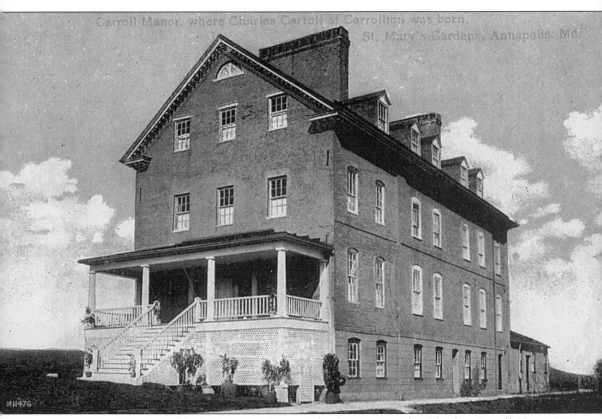

Carroll Manor, where Charles Carroll of Carrollton was born. St. Mary's Gardens, Annapolis, Md.

CARROLL MANOR. This enormous structure, also known as "The Charles Carroll House," is especially distinguished as the only surviving birthplace of a Maryland signatory of the Declaration of Independence. He was also the only Catholic signatory, significant at the time because Catholics were not held in very high esteem due to the stronghold the Catholic Calverts had on the colony prior to the Protestant "revolt." Carroll's grandfather was the first attorney general of Maryland and built a small house that was later connected by an 11-foot passageway to a house built by his son. The third Charles (the signer) added a small library to house the books acquired during his education at European schools, then some boxwood gardens, and finally, in 1790, he added another story. Charles Carroll was elected to both the Maryland State and U.S. Senates after which he performed the rare act of freeing all of his slaves. The town of Carrollton in Prince George's County is named after him.

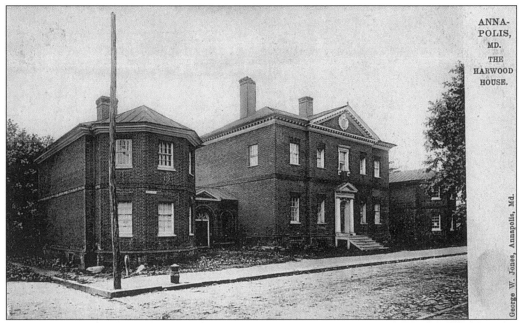

THE HARWOOD HOUSE. Known also as the Hammond-Harwood House, this was another fine effort to bring Georgian architecture to American shores. Originally built between 1774 and 1776 by Matthias Hammond, it was left to a succession of relatives, eventually ending up in the Chase Harwood family. The photograph on this card dates prior to 1906.

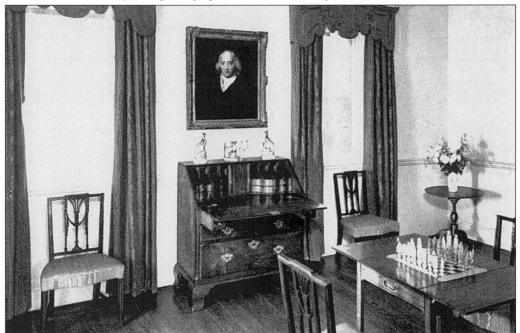

INTERIOR VIEW. This is the game room of the Hammond-Harwood House (*c.* 1910), no doubt enjoyed by Hammond's nephews, John and Philip. Hammond's lawyer, Judge Jeremiah Chase, kept an office in the home and later purchased the house. Daily tours are given today by the Hammond Harwood Association.

29

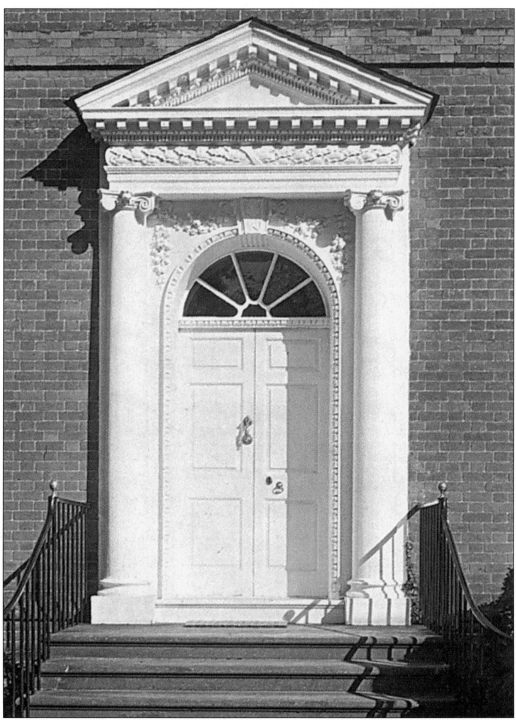

DOORWAY TO HAMMOND HARWOOD HOUSE. This ornate entranceway is said to be the finest colonial doorway in America and is studied by art and history students all over the world. The style is known as Rococo, and if you look closely, you can see garlands of flowers, ribbons, and acanthus leaves.

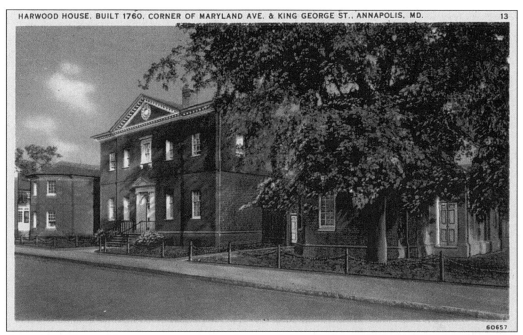

60657

ANOTHER VIEW. This is an artistic rendering of the Hammond Harwod House showing a neatly maintained Maryland Avenue. This type of structure is what Europeans considered a "townhouse." What we call a townhouse today is on a somewhat smaller scale.

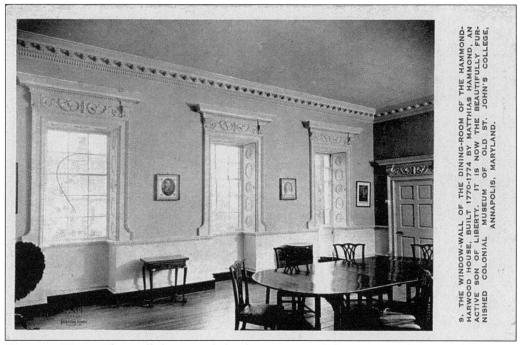

9. THE WINDOW-WALL OF THE DINING-ROOM OF THE HAMMOND-HARWOOD HOUSE, BUILT 1770-1774 BY MATTHIAS HAMMOND, AN ACTIVE SON OF LIBERTY. IT IS NOW THE BEAUTIFULLY FUR-NISHED COLONIAL MUSEUM OF OLD ST. JOHN'S COLLEGE, ANNAPOLIS, MARYLAND.

WINDOW WALL. This wall dominated the dining room of the Hammond Harwood House in what is now the Colonial Museum of Old St. John's College. When Hester Harwood died in 1924, all of the furniture and beautiful antiques were scattered by the auctioneer.

ST. ANNE'S EPISCOPAL CHURCH. This church with its magnificent spire is, of course, the focal point of Church Circle. St. Anne's Church was founded in 1692, but the church that stands on the site today is actually the third building and was constructed in 1858. A silver communion service was presented to St. Anne's in 1695 by King William III and is used to this day for special ceremonies and is occasionally put on display. Two signatories of the Declaration of Independence, Samuel Chase and William Paca, regularly attended services and were active in the parish. The homes of these two patriots are also historic landmarks.

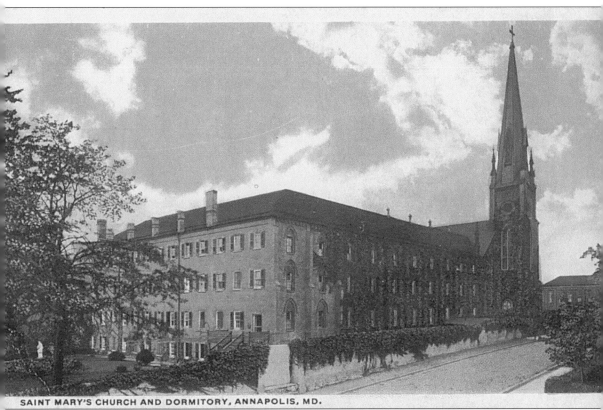

SAINT MARY'S CHURCH AND DORMITORY, ANNAPOLIS, MD.

SAINT MARY'S CHURCH AND DORMITORY. The actual construction of this 7,000-square-foot church was accomplished with the help of Redemptorist novices, seminarians, and brothers. When Catholics lost control of the government in 1689, a public law was passed that prohibited public worship, and even prohibited Catholics from holding public office. Had it not been for the commitment to religious freedom of Charles Carroll, St. Mary's might well have just faded away. He had a chapel built on his own property (conveniently located right behind the church), and parishioners were able to attend Mass and receive the sacraments of their faith clandestinely. Today, St. Mary's is a thriving Catholic community and operates both an elementary school and a high school.

OLD PACA MANSION. Frequently referred to as the Carvel Hotel because a hotel was added to the north side of the mansion in 1907, this card is postmarked 1908, just one year after the hotel opened. William Paca served in the Revolutionary War with distinction, was active in both the Continental Congress and the new government and served three terms as governor.

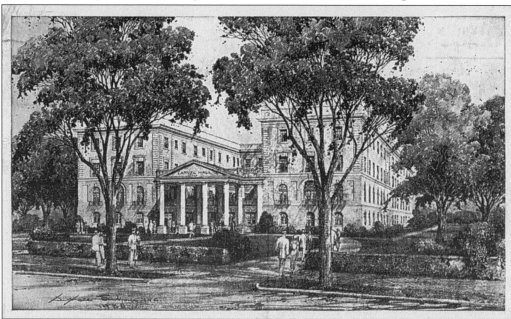

CARVEL HALL HOTEL. The hotel complex was an important part of the Annapolis social scene for many years but was nearly demolished until the Historic Annapolis Foundation once again came to the rescue. On the back of this card a lady named Jane relates to a friend in Sewickley, Pennsylvania in November 1941 that Annapolis is "having summer weather" and that "Horace sits in the sun all day." We hope that Horace is a pet and not a husband.

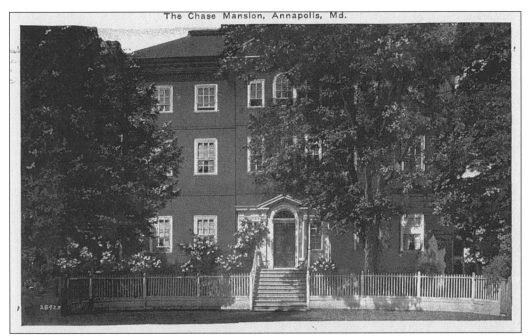

CHASE MANSION. This is the only three-story colonial house in Annapolis. Although named for Samuel Chase, it was actually completed by Governor Lloyd. It was occupied by Hester Ridout until her death in 1888 when she instructed that the home be turned into a shelter for "aged, infirm, and destitute women."

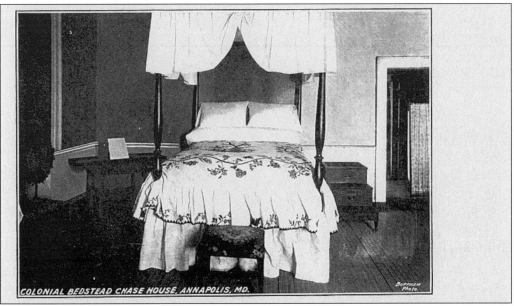

COLONIAL BEDSTEAD. This bedroom furniture is but one example of furnishings from Chase House, whose interiors are considered to be among the finest and most beautiful in the entire state. When the original furnishings cannot be located or restored and sufficient funds can be raised, artisans (using tools and materials available to the colonists) are frequently employed to make copies of the missing pieces.

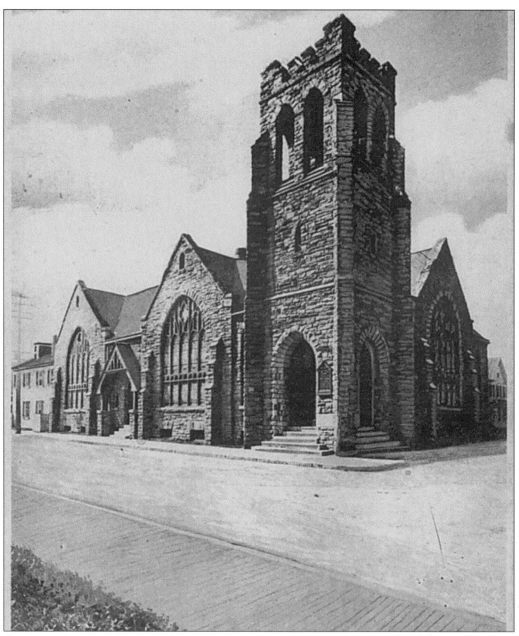

COLLEGE AVENUE BAPTIST CHURCH. This magnificent old stone church complete with ramparts and bell tower was another tragic victim to progress and the need for more buildings to meet the goals of state government. In 1899, it began life as the Baptist Church of Maryland and, in 1903, became the College Avenue Baptist Church. The property was purchased by the State of Maryland in 1968, and the Church began anew as Heritage Baptist Church and thrives today on Forest Drive. Today an office building stands on the original site of the church. Happily, the building plans committee voted to recreate the unique interior sanctuary style of the original building and, as much as possible in what has become an Annapolis tradition, share the old with the new. Today, it is generally considered to be the finest church building in the city.

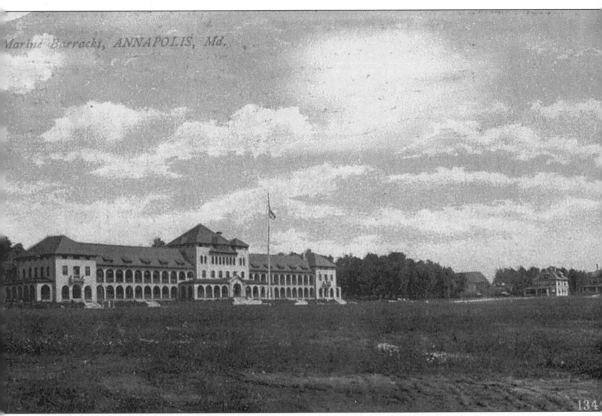

Marine Barracks, ANNAPOLIS, Md.,

134

MARINE BARRACKS. In this turn-of-the-century view, the Marine barracks stands as alone and forlorn as the sender of this postcard. Identified only as "Holmes," he is apparently making his way home just after Christmas. Evidenced by the postmark, December 26, 1907, he is traveling through Cumberland in Western Maryland with his eventual destination being Winchester, Virginia. He expresses to his friend Newt his hope that "it will suit you to meet us their [*sic*]."

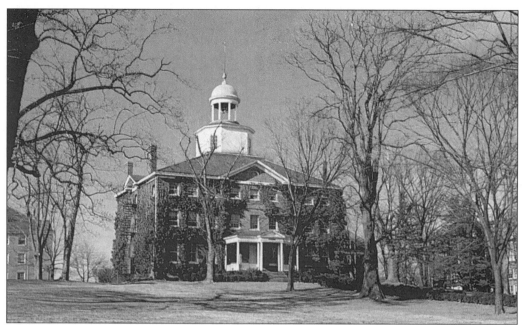

McDowell Hall. Originally intended to assume the role of Governor's mansion and residence, this building became McDowell Hall, the "Great Hall" of St. John's College. It is named for John McDowell, the first president of the college. This is the center of student activities and an important historic landmark of early Annapolis.

ST. JOHN'S COLLEGE, ANNAPOLIS, MD.

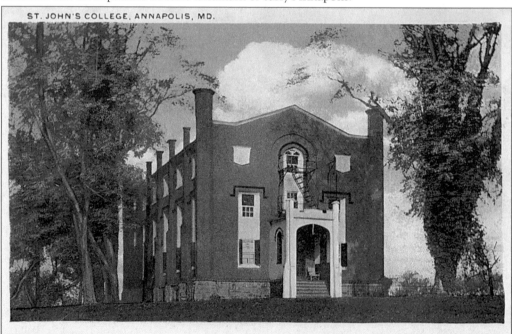

St. John's College. Although living in the shadow of the famous U.S. Naval Academy, St. John's stands alone as an excellent liberal arts college and has achieved national prominence as "the school of great books" for its unique curriculum. Additionally, it is the third oldest college in the country behind Harvard and the College of William and Mary.

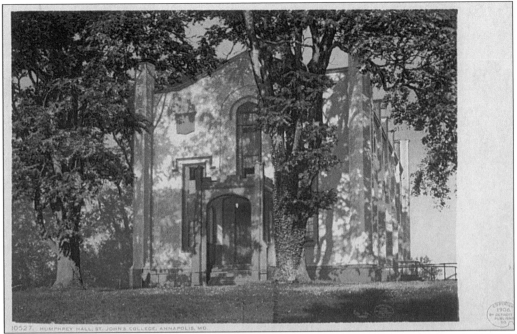

HUMPHREY HALL AT ST. JOHN'S. St. John's was founded in 1696 as King William's School, and its curriculum was that of a university preparatory school. It was finally chartered (after several attempts) as St. John's College and was the first American school to prohibit religious discrimination. Despite the suggestion in the name, the school has absolutely no religious affiliation.

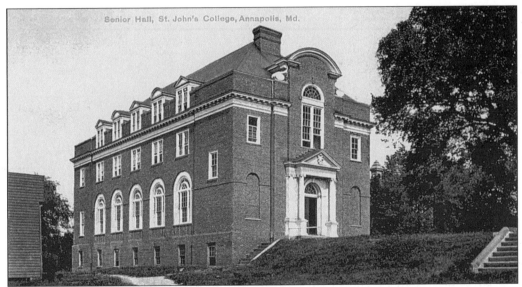

SENIOR HALL, ST. JOHN'S COLLEGE. St. John's has a small enrollment, only about 400 students, and a faculty to student ratio of only 8 to 1. Few schools of any type can boast this. Each student takes an identical, required curriculum, including two years of Greek! Early graduates of the school include two of George Washington's nephews and Francis Scott Key, who went on to write the national anthem.

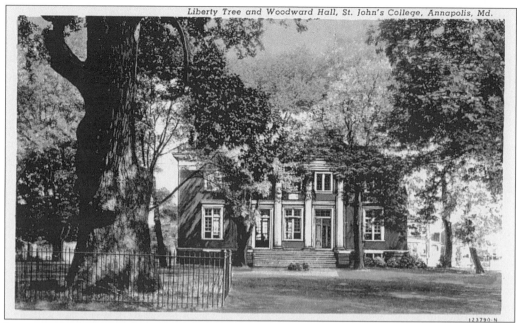

Liberty Tree and Woodward Hall, St. John's College, Annapolis, Md.

LIBERTY TREE AND WOODWARD HALL. Estimates of the age of this tree run between 400 and 600 years old and a mystique has risen about it. The Puritan settlers are said to have made a peace treaty with the Susquehanna Indians at this spot in 1652. This particular postcard was written by a student in October 1948 and makes reference to a very busy schedule.

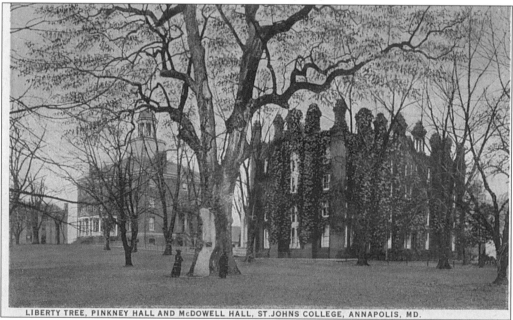

LIBERTY TREE, PINKNEY HALL AND McDOWELL HALL, ST. JOHNS COLLEGE, ANNAPOLIS, MD.

LIBERTY TREE, PINKNEY HALL, AND McDOWELL HALL. Pinkney Hall was originally designed as a men's dormitory. The residences are now coed on staggered floors. "The Sons of Liberty", a loosely organized group of patriots, are said to have planned their seditious activities under the branches of the tree. Now, it is the site of the annual springtime croquet match between the college and the Naval Academy.

40

Three
SCHOOL FOR ADMIRALS

The first attempt to train midshipmen began as an experiment aboard the American brig *Somers* in 1842. The original thinking was that qualified and promising teenage volunteers could be trained aboard ship and receive inspiration to pursue a career in the relatively young United States Navy. But, the program, lacking proper planning and experienced leadership, was doomed to fail. A midshipman and two boatswains attempted to take over the ship, were convicted of mutiny, and hanged. Three years later, after re-thinking the training of a future officer, it was decided the proper approach would be a more balanced curriculum consisting of military training and discipline combined with academic training in such practical matters as mathematics, gunnery, and navigation; and natural philosophy and French for fun. Thus, on October 10, 1845 the "Naval School" came into existence at a 10-acre Army post in Annapolis named Fort Severn. There were only 50 midshipmen and seven professors in this first class. In 1850, the name was changed to The United States Naval Academy and studies were expanded into a four-year curriculum with the summers occupied by training cruises. (So far, no one's been hanged on these cruises.) The postcard images on the following pages illustrate aspects of midshipman life, Academy tradition, and historic buildings and monuments. The ranks have swelled from 50 to a brigade of over 4,000 midshipmen (including women beginning in 1976.) The 10-acre fort of ramshackle wooden dwellings has metamorphosed to 238 acres of granite, steel, brick, and modern facilities.

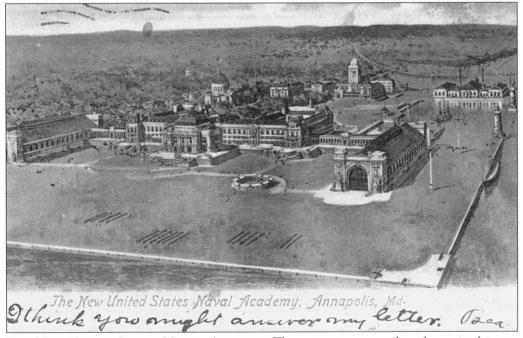

The New United States Naval Academy, Annapolis, Md.

I think you might answer my letter. Pea

THE NEW UNITED STATES NAVAL ACADEMY. These structures were brand new in this rare photograph on a card postmarked in July 1908. Bancroft Hall can be seen in the back and the dome of the chapel is slightly left of center. The note gently admonishes a friend in Washington County, Maryland that "I think you might answer my letter."

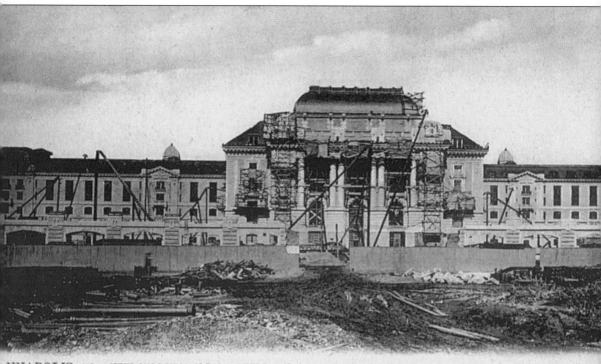

NEW MIDSHIPMAN'S QUARTERS. This photograph image, taken prior to 1906, shows the construction of a new dormitory to house the influx of new midshipmen and the growing requirements of a school that was proving more and more successful as the years passed. However, in 1895, the board of visitors had condemned the new Academy's facilities as inadequate, and Ernest Flagg, a prominent New York architect, was hired to create a new master plan to rebuild the Academy. The construction shown in this photograph reflects part of that plan. In 1903, the brigade of midshipmen had expanded from 4 to 8 companies, effectively doubling the school's enrollment. Finally in 1909, the old Fort Severn was totally demolished.

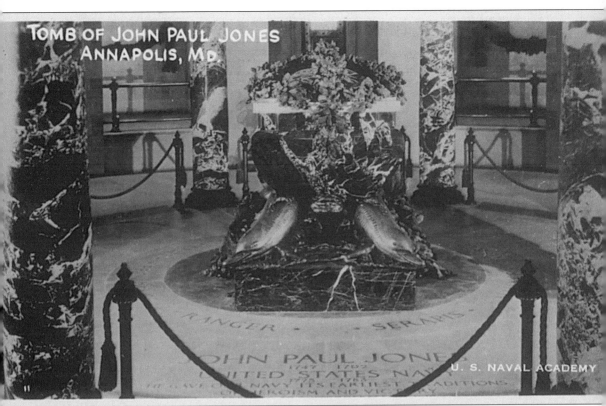

TOMB OF JOHN PAUL JONES. This perhaps most famous of all American naval heroes had quite a journey from the place of his death to his final honors in the Naval Academy Chapel. Despite the fame he had achieved, Jones died alone and poor in a Paris apartment on July 18, 1792. It took over 100 years for the American government to express an interest in having his remains returned to his native country, and an exhaustive effort was launched to find his body in a forgotten cemetery. After several weeks and the destruction of several Paris basements and streets, the remains were located and began a journey that would take the body from Paris to Cherbourg to Annapolis. Feeling that it was fitting for Commodore Jones to be finally laid to rest where he would forever be an inspiration to future Naval leaders, he was finally interred in the crypt of the Naval Academy Chapel on January 26, 1913.

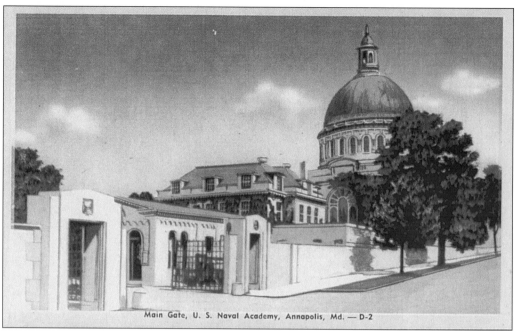

Main Gate, U. S. Naval Academy, Annapolis, Md. — D-2

MAIN GATE, U.S. NAVAL ACADEMY. Remaining substantially unchanged today, this view of the main entrance to the Academy shows the administration building just to the right of the gate and the chapel on the far right. The bronze gates and walkway arches are a memorial to the class of 1907.

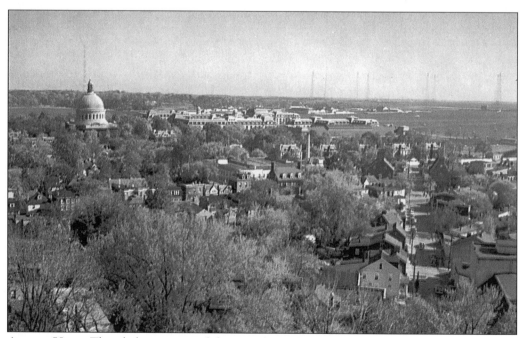

AERIAL VIEW. This skyline aspect of the Naval Academy shows the colonial buildings of the older section of Annapolis. The chapel dome on the left has become the dominant feature of the landscape.

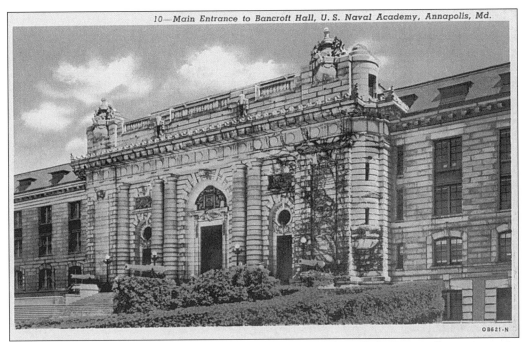

OB621-N

MAIN ENTRANCE TO BANCROFT HALL. Not only is Bancroft Hall the largest dormitory in the world, housing over 4,000 midshipmen, it is also one of the largest buildings in the world and sits on over 5 acres. Several wings have been added over the years as the population has increased. It was named after George Bancroft, secretary of the Navy and founder of the USNA.

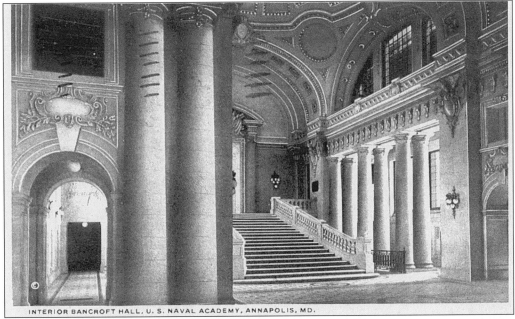

INTERIOR BANCROFT HALL, U. S. NAVAL ACADEMY, ANNAPOLIS, MD.

INTERIOR OF BANCROFT HALL. The dormitory's interior is every bit as impressive as its exterior with high, columned ceilings and ornately decorated stairways and archways. The card, dated July 18, 1916, tells a San Francisco acquaintance of a planned "motor" trip to Loch Raven (in Baltimore), a luncheon party, and catching the "5:10" to New York.

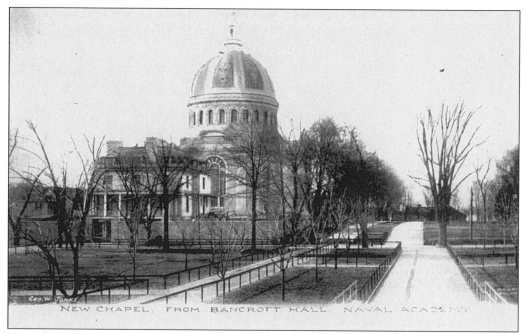

NEW CHAPEL, USNA. The first service in the new chapel was held on May 28, 1908, and this postcard dates back to approximately that time. The structure stands with Bancroft Hall as among the most imposing buildings at the Academy. This view is from Bancroft Hall.

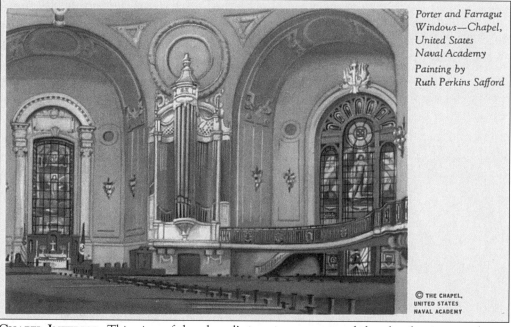

Porter and Farragut Windows—Chapel, United States Naval Academy

Painting by Ruth Perkins Safford

© THE CHAPEL, UNITED STATES NAVAL ACADEMY

CHAPEL INTERIOR. This view of the chapel's interior was painted shortly after its completion and emphasizes the recessed archways containing stained glass images named the "Porter" and "Farragut" windows. A year after the first service was held here, the bronze doors of the chapel were unveiled and dedicated to the class of 1868.

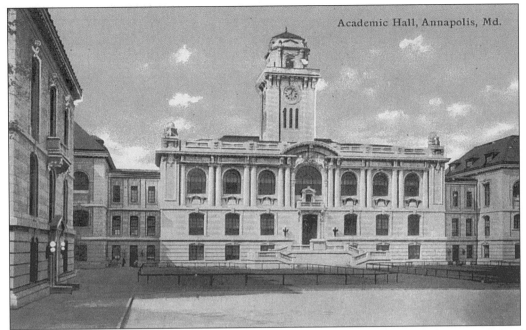

Academic Hall, Annapolis, Md.

ACADEMIC HALL. This early photo of the Academic Hall shows the solidity of construction of the new Naval Academy in the early years of the twentieth century. Obviously the designers and architects knew by this time that the college was here to stay. Ornamental details shared equal status with function in design concepts of the day.

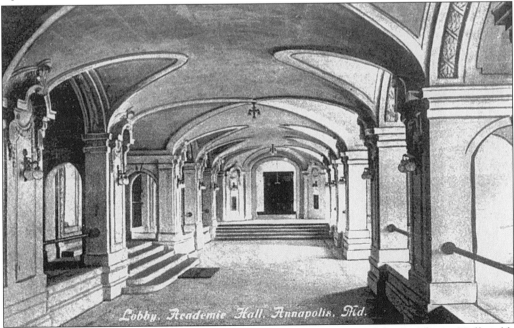

Lobby, Academic Hall, Annapolis, Md.

LOBBY, ACADEMIC HALL. This interior view of the reception area of the Academic Hall yields further evidence that conveying an impression of strength and timelessness to the visitor was as important to the builders as the purpose of the building itself. This particular card has an August 1911 postmark.

47

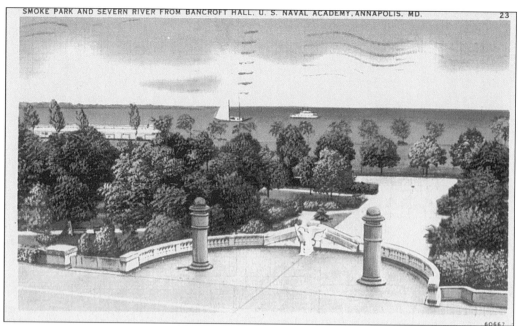

SMOKE PARK AND SEVERN RIVER VIEW. This is the magnificent view of the Severn River that greets the midshipman from the Bancroft Hall dormitory. It serves as a constant reminder that the eventual destination of the officer in training is the sea. The card was sent to a tourist's father in Kentucky in June 1940.

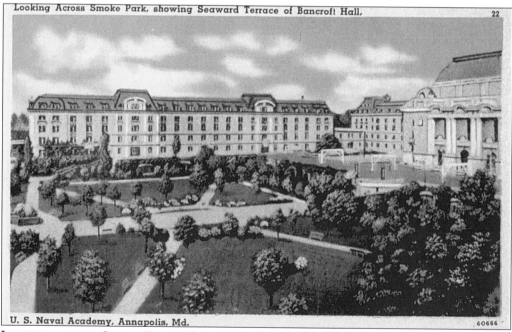

U. S. Naval Academy, Annapolis, Md.

LOOKING ACROSS SMOKE PARK. This aspect of the front of Bancroft Hall indicates that the landscaping and appearance of the grounds figured into the overall impression of stability the designers wanted to create. The tree-lined walks and gardens known as Smoke Park are meticulously maintained.

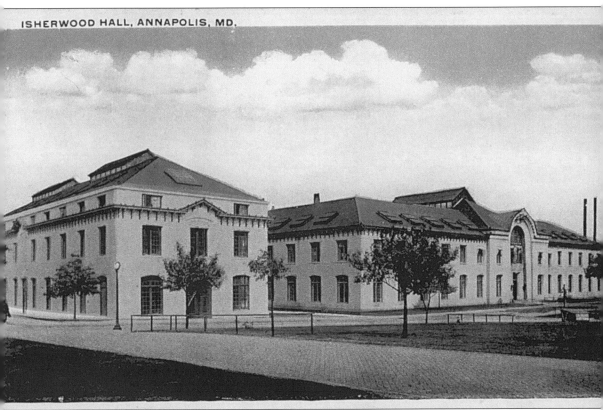

ISHERWOOD HALL, ANNAPOLIS, MD.

ISHERWOOD HALL. Isherwood, the marine engineering building, was completed in 1905 (this picture was done sometime after 1918.) This building was razed in 1982, along with two others, Griffin and Melvile Halls. Alumni Hall, the brigade activities center, stands in its place today. For a time, until Nimitz Hall was completed, the technical portion of the Naval Academy Library was stored here.

MICHELSON AND CHAUVENET HALLS. These two academic buildings reflect a newer style of architecture. Although not ornately detailed like the earlier structures, the columns and raised foundation give an unmistakable sense of strength. Albert Michelson, a Naval Academy graduate, was the first American to win the Nobel Prize. The building that was named after him is the site on which he performed experiments leading to the first accurate measurement of the speed of light. (The total cost of materials used in the experiment was less than $10.) William Chauvenet is honored for being the first professor of mathematics and navigation when the fledgling school was founded in 1845. His classroom was considerably less comfortable than the ones in this building, but the more modern concepts in the design of these buildings represent very well the newer advances in technology.

MAHAN HALL. This was the first building completed in the Academic group (including Maury Hall and Sampson Hall) and served as the Academy Library and auditorium for many years. It occupies one end of a mall which leads to the main entrance of Bancroft Hall.

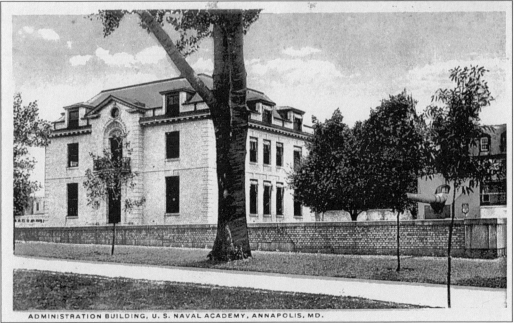

ADMINISTRATION BUILDING, U. S. NAVAL ACADEMY, ANNAPOLIS, MD.

ADMINISTRATION BUILDING. This view of the main Administration Building dates back to around 1920. It still occupies a very prominent spot in its location near the main gate and contains the offices of the superintendent of the Naval Academy and the academic dean and provost.

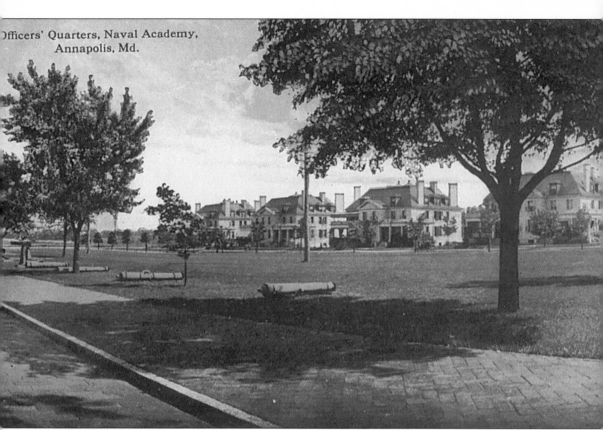

Officers' Quarters, Naval Academy,
Annapolis, Md.

OFFICERS' QUARTERS. Some of the noteworthy features of this early 1920s scene of the Academy's officers' quarters are the brick street and walkway. The ships' cannon barrels lining the drive offer an interesting contrast to the tranquillity of the neighborhood. Buchanan House is the permanent home for every Academy superintendent. Many of the school's senior officers and instructors have been billeted in these houses over the years, and a temporary assignment to the Academy is a necessary item on the resume of the future admiral.

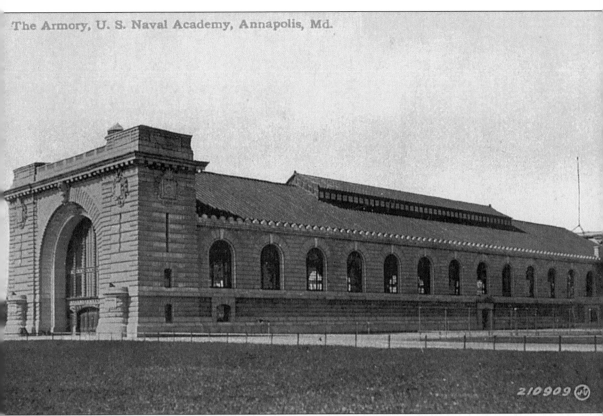

210909

THE ARMORY. Also known as Dahlgren Hall, this building's original use was as an armory and close order drill area. Construction of Dahlgren Hall was completed in 1903, and it was decided to name the armory after Rear Admiral John A. Dahlgren, inventor of the rifle bore cannon installed on both the USS *Monitor* and the CSS *Virginia* in the Civil War. The building is chiefly used today as a midshipman activities center, and several formal dances a year are held here. There is also an ice rink and the popular Drydock restaurant, all fitting peacetime uses for an armory.

eneral View of Harbor and U. S. Naval Academy at night, Annapolis, Md.

6

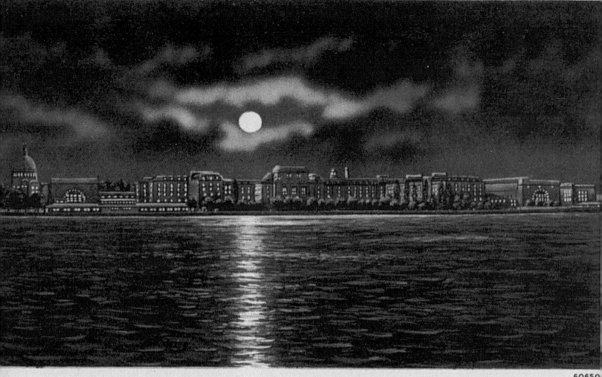

60650

NOCTURNAL PEACE AT THE USNA. This nighttime scene of moonlight on the tranquil waters of the Academy's harbor is in stark contrast to the almost frantic level of activity that governs every aspect of midshipman life during the day. Even in rare moments of leisure, when not engaged in drilling, training, classes, or athletics, the midshipman is advised to go about his or her business like a "man with a mission." Except on weekends when escorting family and friends around the reservation, casual strolls do not happen.

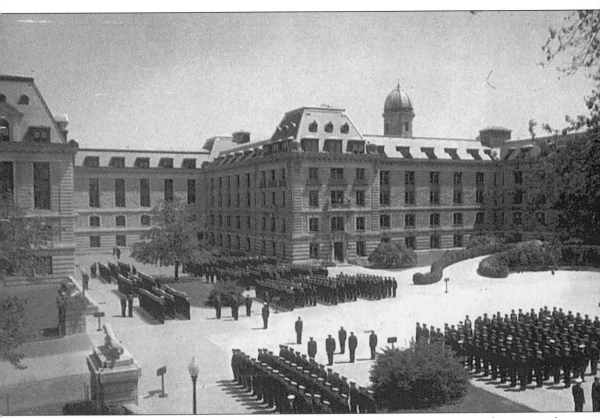

MIDSHIPMEN IN FORMATION. Drills, marching, parades, and formations are a very large part of life at the Naval Academy. This image and many on the pages to follow will emphasize this practice. Words and phrases like "teamwork" and "esprit de corps" come to mind to explain this aspect of the daily routine. But, it is more than this. Academy training is aimed at instilling a sense of pride, responsiveness, and the ability to work through the ranks to positions of leadership within the brigade, and later in the fleet. To the outsider, Academy training, especially that of a plebe (or freshman), seems harsh, impersonal, and even cold. But this is a school for *leaders*. This is a school for *warriors*. This is a school for *admirals*.

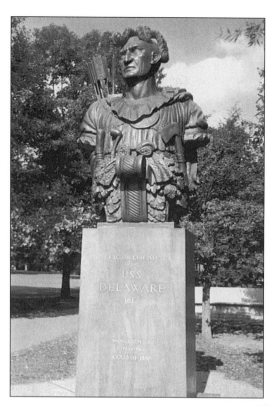

TECUMSEH. This statue, named after the great Shawnee chieftain and warrior, was originally the figurehead of the wooden ship, USS *Delaware*. After the ship burned, the figurehead was rescued and brought to the Academy in 1866. It was cast in bronze by the class of 1891 and sealed within are a class ring and the class roster.

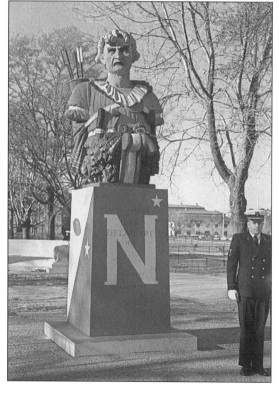

FESTIVE TECUMSEH. The statue, looking a little less imposing, is painted in blue and gold (the Navy's colors) with a red tunic for special occasions like the Army/Navy game, Commissioning Week, and Alumni Weekend. A midshipman guard is present constantly during these times. Oh yes, the paint is water based.

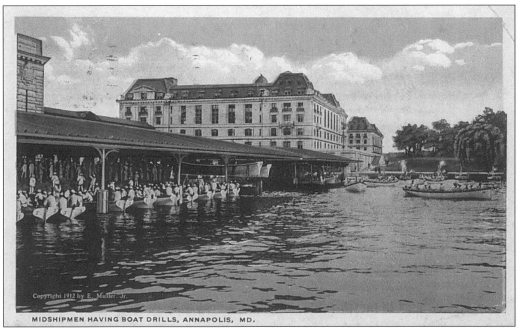

MIDSHIPMEN HAVING BOAT DRILLS, ANNAPOLIS, MD.

BOAT DRILLS. This card contains a reprint of a 1912 E. Muller Jr painting of midshipmen going about the business of learning seamanship, preparing to launch their craft into the Severn River. This postcard, sent from Annapolis on June 3, 1930, contains a note from Doris to a friend in Springfield, Massachusetts and praises the beauty of the Naval Academy.

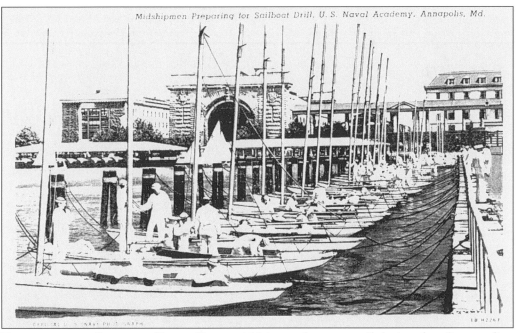

Midshipmen Preparing for Sailboat Drill, U. S. Naval Academy, Annapolis, Md.

PREPARING FOR SAILBOAT DRILL. Every midshipman learns to sail during that first grueling summer as a plebe. The Academy actually maintains quite a fleet, including lasers, 420-class dinghies, J-22s and J-24s, 44-foot sloops, and even larger offshore racing boats.

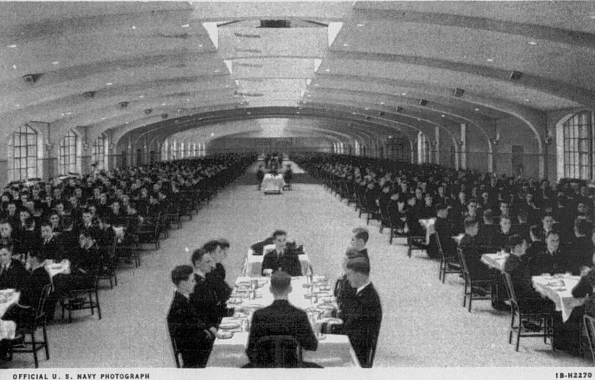

OFFICIAL U. S. NAVY PHOTOGRAPH

1B-H2270

NOON DAY MEAL, BANCROFT HALL. The entire brigade of midshipmen eats each meal together. This is the largest mess hall in the world. The meals are served family style and delivered to each table in a matter of minutes by over 300 civilian mess attendants. Time is allotted for grace or silent meditation before the meal and, any announcements affecting the brigade are made during the meal. The unfortunate plebe who has not been in the practice of good table manners prior to beginning his career is quickly brought up to date. The message on this postcard has to do with a lacrosse match between Navy and an unidentified school in April 1952. The writer laments to his parents in Port Elizabeth, New Jersey that his team had been soundly defeated by the "mids" by a score of 4 to 1.

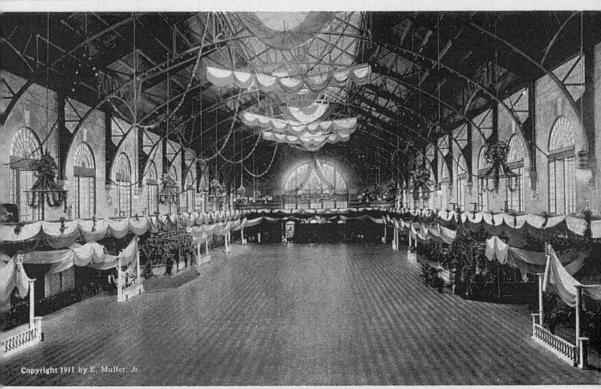

Copyright 1911 by E. Muller, Jr.

DECORATIONS FOR A DANCE, INTERIOR OF ARMORY, U. S. NAVAL ACADEMY, ANNAPOLIS, MD.

DECORATIONS FOR A DANCE. This 1911 image shows the interior of the Armory stylishly decorated for one of several formal functions held throughout the year. Along with academics and boating, midshipmen are thoroughly schooled in the social graces. Way back in 1865, Rear Admiral David D. Porter added both athletics and social functions to the Academy routine, causing a local reporter to quip that the USNA had become "Porter's Dancing Academy." Then, as now, an officer was expected to participate in the social functions and traditions of the military community. After all, there's more to the seafaring life than barnacles and radar scopes. Young women and men from nearby towns and colleges are invited to participate in these gatherings and become familiar with Academy life.

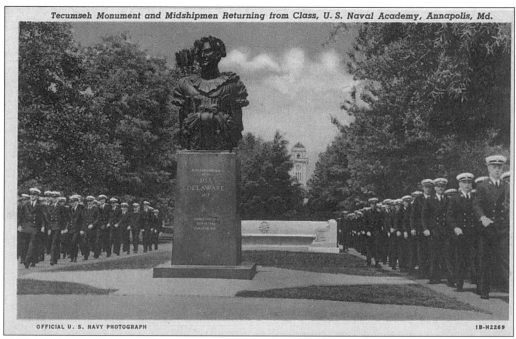

STRIBLING WALK. The path by the statue of the warrior Tecumseh is called Stribling Walk, and midshipmen march along this route from their dormitory to classes. This bust is referred to as the "god of 2.0" during exam time, a 2.0 being a passing grade. Furthering the superstition, "middies" give the figurehead left-handed salutes and pitch pennies at it for luck before exams.

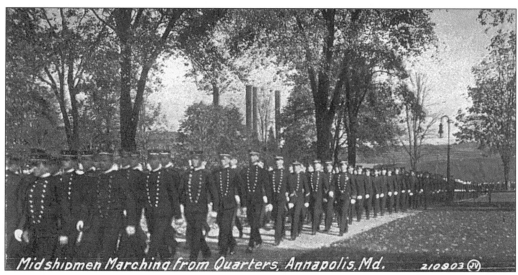

MARCHING FROM QUARTERS. In another time, but in the same place, midshipmen again trod the well-worn path to begin their studies for another day. The uniforms have changed over the years, but the traditions and customs remain constant.

60

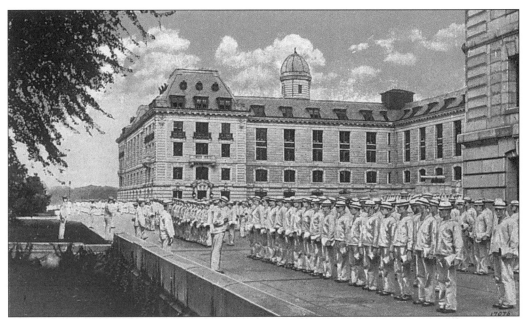

ROLL CALL. In another custom dating back to the founding of the Academy, midshipmen line up outside the dormitory for morning formation and roll call. The brigade has obviously grown much too large to answer individually; instead squad and company commanders report the status and attendance of their charges to the brigade commander.

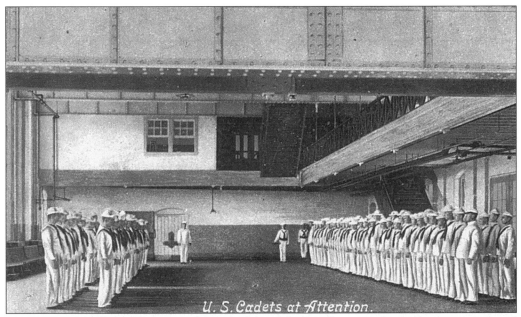

U. S. Cadets at Attention.

U.S. CADETS AT ATTENTION. In the early days of the Academy, student officers were referred to as "Naval Cadets." This term was changed to "midshipman" in the summer of 1902. This scene probably takes place in the Armory and shows new plebes being instructed in close order drill.

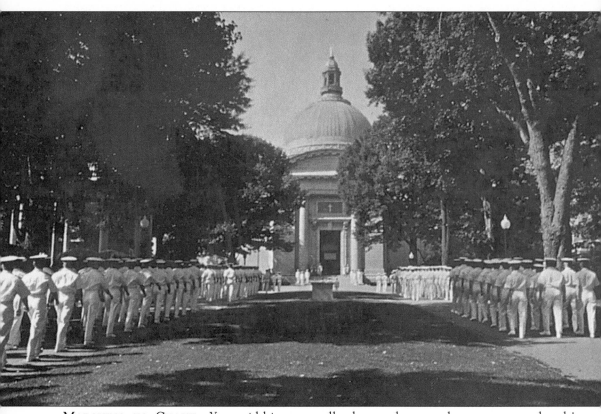

MARCHING TO CHAPEL. Yes, midshipmen really do march everywhere, even to church! Midshipmen are given their choice of attending Protestant or Catholic services at the Academy's chapel or they can attend other churches or temples in Annapolis as part of a "church party." The Academy chapel was built on the highest ground in the Academy "yard" and is also known as the "Cathedral of the Navy." The cornerstone was laid by Admiral George Dewey in 1904. It was enlarged and remodeled in 1940, increasing its capacity from 1,600 to 2,500. The crypt of John Paul Jones is reverently displayed beneath the chapel and is accessible by entrances on either side.

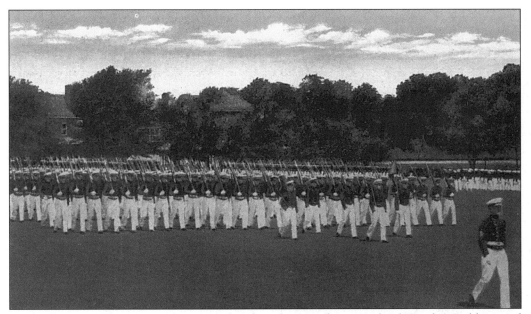

DRESS PARADE. This impressive spectacle takes place on the grounds of Worden Field, named after Rear Admiral John Worden, commander of the USS *Monitor*. These parades are graded and figure into the overall score of the competition for "Color Company," a highly sought-after honor awarded at the end of the academic year.

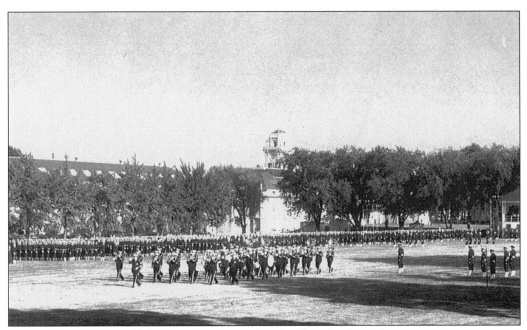

PASS IN REVIEW! The U.S. Navy Band precedes the Brigade of Midshipmen as they prepare to pass by the Naval Academy senior officer staff in a splendid display of precision drill and ceremony. The public is invited to attend these events.

LOVERS LANE. Practically every college campus has one, but this walkway is also known as "The Admiral's Walk." Plebes are not permitted to use this area. It is considered a privilege earned by surviving the rigors of the first year. This 1912 E. Muller Jr piece expresses the serenity of a fall day.

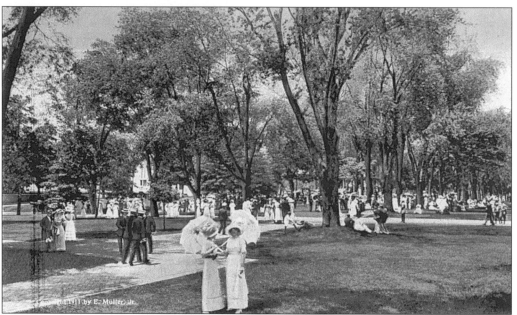

JUNE WEEK ON LOVERS LANE. The most interesting feature of this 1911 drawing is the style of dress of the day—hats and parasols for the ladies, straw hats for the gentlemen, and if you look very closely to the left of the big tree, you can see a young gentleman in "knickers."

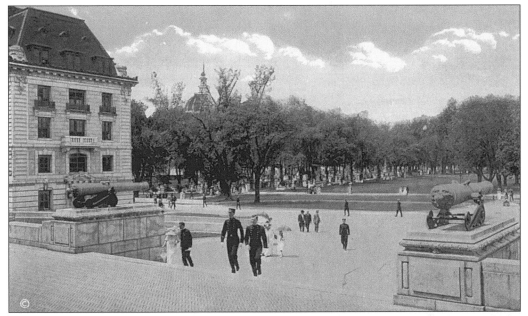

VIEW FROM BANCROFT HALL. In what is most likely a weekend scene, midshipmen can be observed escorting family and friends around the grounds and walks of the dormitory. The cannons stand as sentinels at the top of the stairs, reminding the future officers of what lies ahead.

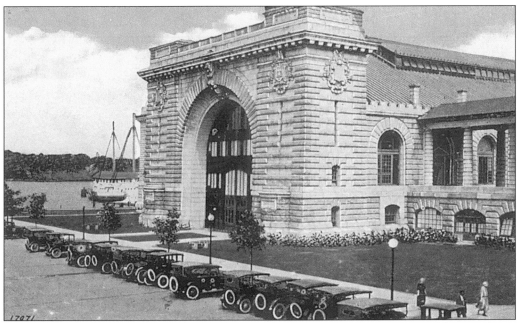

GYMNASIUM. The subject of this postcard is the Academy gymnasium where midshipmen learn that a fit body contributes to the fitness of the mind. Although not specifically identified, this image probably dates back to the early 1930s.

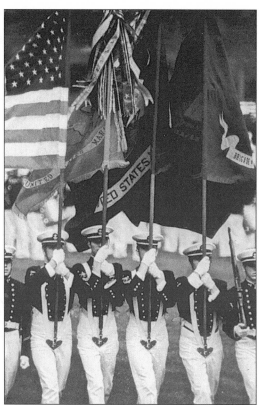

COLOR GUARD. Since troops first took to the field, it has been considered a singular honor to carry the colors into battle or on the parade grounds. These midshipmen are carrying the American flag, the Navy flag, and the Brigade of Midshipmen flag.

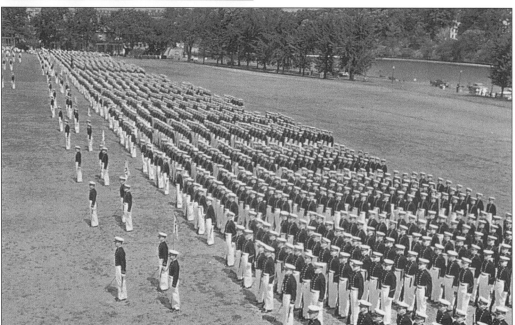

PARADE FORMATION. The brigade is lined up in companies on Worden Field prior to filing off in another review. College Creek can be seen in the background. Worden Field is bordered by College Creek and the Severn River and is situated across from the Naval Hospital.

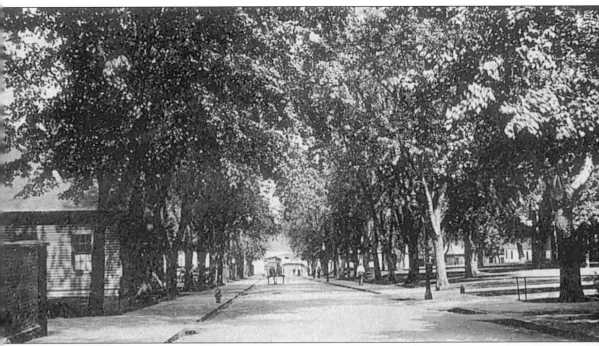

MAIN WALK. This extremely rare photograph shows the main thoroughfare of the Naval Academy at Fort Severn before the dream of establishing a major Naval university was realized. Before the turn of the century, many traditions and customs had yet to come into their fullness. The academic format was far less sophisticated. Each class selected its own colors until 1892 when it was decided on blue and gold to forever represent the young institute. "Bill the Goat" was assigned to be the Navy's mascot in 1893. In 1899, the Naval Academy motto became "Ex Scientia Tridens" or "From Knowledge, Sea Power." The horse and carriage coming up the walk are in vivid contrast to the awesome power and technology of today.

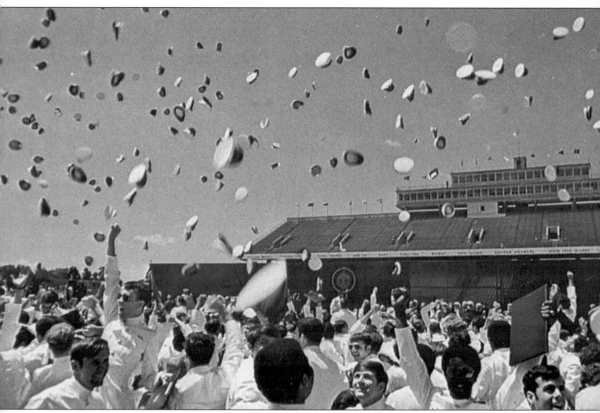

OH, HAPPY DAY! In fact, this is the happiest of days in the life of a midshipmen, a milestone in their careers that will be referred to again and again over the course of future assignments. Today, they are commissioned ensigns in the Navy or second-lieutenants in the Marine Corps depending on their choice of assignments. Prior to 1912, midshipmen were not commissioned until they had served two years at sea. Additionally, they have a bachelor of science degree. It was not until 1931 that the curriculum was accredited by the Association of American Universities. Even then, it took another two years before graduates were awarded a college degree and the military academies were put on an equal footing with their civilian counterparts. In 1937, Congress voted to award the degree to all living graduates. On this day, the careers of future admirals have been launched.

Four

ROADWAYS AND
WATERWAYS

Infrastructure—that curious word describes the network of roads, utilities, and transportation systems that keeps a city vital and healthy. For the city's infrastructure operates like the veins in a body carrying the vital nutrients to the different organs. Again like the body, the infrastructure must grow and develop to meet the needs of a growing city with an expanding population. Through the postcard images and the brief messages on the backs, it is interesting to learn about the early days of travel throughout the area. What we would consider a brief journey across the interstate highways of today would take hours, even days a few decades ago, and was generally planned in advance and accomplished in stages. The rivers and creeks contributed to necessary travel, for frequently, the only way to cross a body of water was by a ferry. Then, as now, the bay and its tributaries provided citizens with a living as well as sport, and Annapolis grew to become the sailing capital of the world, a paradise for boaters and fishermen. The images on these cards, some quite rare, others common, also offer clear evidence of a city trying to work a growing network of roads and businesses into the landscape without detracting from its beauty and without destroying the fragile evidence that keeps open a door to the area's past.

TOURIST PAMPHLET. This is the cover of a very early 1900 pamphlet from the Washington, Baltimore & Annapolis Electric Railroad Co. (WB&A) and entices the tourist with glowing descriptions of colonial attractions and the U.S. Naval Academy, quite new at the time. Oh yes, they also mention the fact that theirs is the only vehicle that will take you right to the gate.

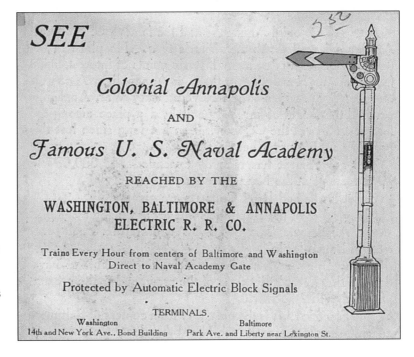

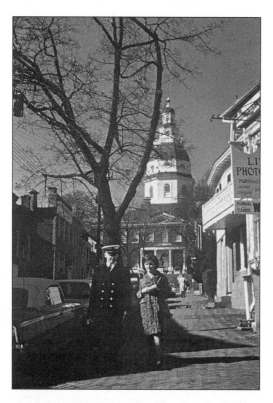

IN OLDE ANNAPOLIS. This is a relatively contemporary view of a street in downtown Annapolis. This late fall photograph of a midshipman taking a stroll with a lady friend highlights the well-maintained old brick sidewalk, the preserved buildings, and the majesty of the State House rising in the background.

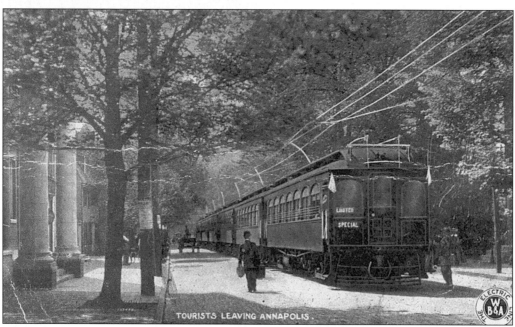

TOURISTS LEAVING ANNAPOLIS. This postcard was published by the WB&A Electric Railway Company and shows a six-car electric train with tourists departing Annapolis and heading for Washington. The cost from Baltimore was $1 and the charge from Washington was $1.50, a pretty hefty transportation fee.

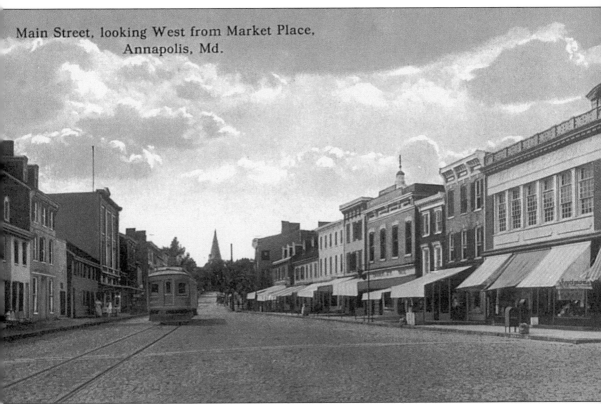

Main Street, looking West from Market Place, Annapolis, Md.

MAIN STREET, LOOKING WEST. This is what the tourist saw while standing at the bottom of Main Street at Market Place in the early years of the twentieth century. Incredibly, the view has hardly changed! Today, rather than the electric train, you will see cars at the curb with meters hungrily swallowing coins. But, the buildings have been kept unchanged and are now occupied by eclectic and interesting shops with an occasional drug store and gift shop to be found. The spire of St. Anne's can still be seen at the top of the street (all roads in Old Annapolis lead to Church Circle), and the Franklin rod atop the State House dome can be seen on the right. (Well, okay there is a Burger King about two-thirds of the way up the street on the left, but they put the entrance in the alley.)

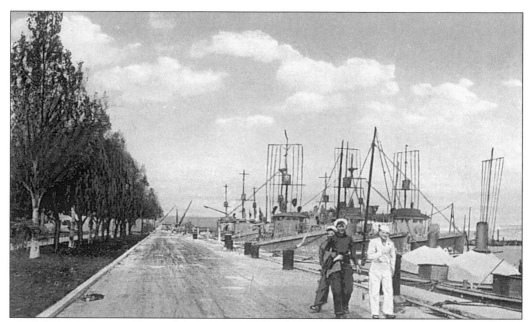

ROAD ALONG SANTEE BASIN. This view, *c.* 1920, shows sailors enjoying some rare free time in port along the dock named for the USS *Santee.* The *Santee* was an early training vessel used to acquaint Naval Academy midshipmen with the skills they would need at sea.

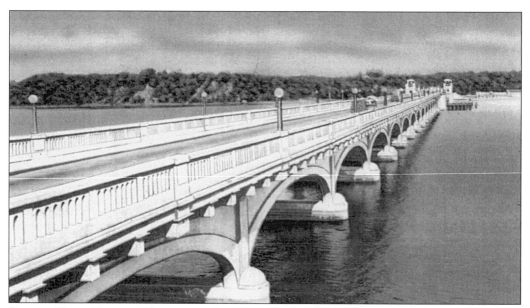

SEVERN RIVER BRIDGE. This is one of a series of bridge thoroughfares needed to convey motor vehicles in and out of Annapolis. Although relatively old, it is well lit and still handles a very heavy volume of traffic.

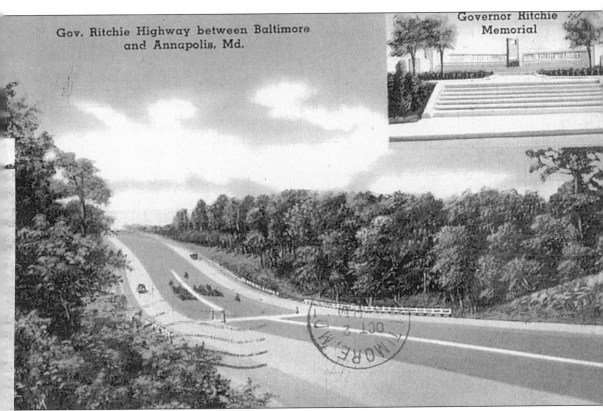

Gov. Ritchie Highway between Baltimore and Annapolis, Md.

Governor Ritchie Memorial

RITCHIE HIGHWAY. This road, named after a former Maryland governor, has been an unfortunate casualty of civilization. This 1944 drawing shows it to be a picturesque drive through rolling countryside. For many years, it was the major highway linking Annapolis with Baltimore. The scenery along this route is not so rolling and lovely and green today. Although it has been widened and improved, this once scenic roadway has succumbed to an artery of stoplights, gas stations, fast food restaurants, and shopping centers. Fortunately, an interstate highway was finally opened in the early 1990s, and I-97 has significantly reduced the gridlock between the two cities.

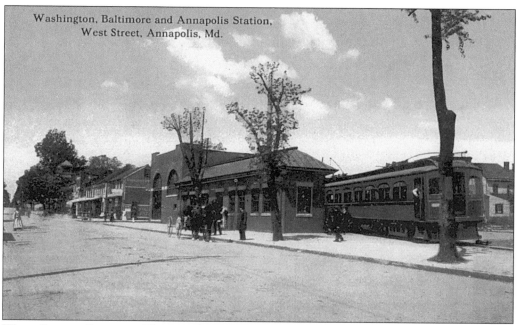

Washington, Baltimore and Annapolis Station, West Street, Annapolis, Md.

WEST STREET STATION. This was the Annapolis hub for the WB&A Electric Railroad. The carriage parked at the curb provided taxi service to other parts of the city. Essential to the tourist industry, the electric railway provided a vital service to the cities of Baltimore, Washington, and Annapolis for many years.

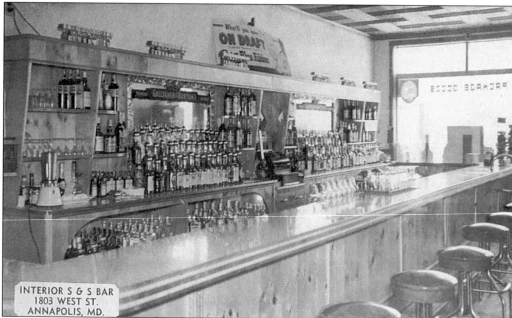

INTERIOR S & S BAR
1803 WEST ST.
ANNAPOLIS, MD.

S&S BAR. Once a popular watering hole for the weary traveler (and the thirsty local), it is unknown what became of this West Street establishment. It is no longer in business and West Street has been re-numbered, so it is difficult to determine what stands in its place today. The mention of the new Chesapeake Bay Bridge on the back of the card probably dates it to the early 1950s.

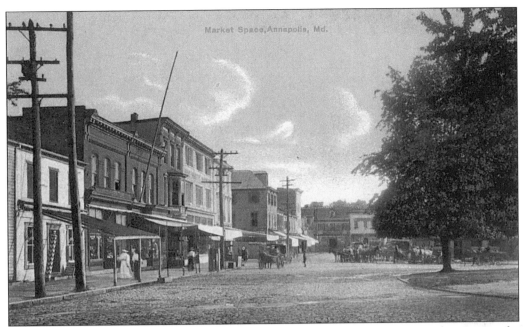

MARKET SPACE. This view of Market Space, *c.* 1910, shows the major center of commerce for Annapolis. To the left would be Main Street. In evidence are utility poles carrying a relatively new technology—electricity—to light up the homes and businesses at night. Today, this area is filled with lively bistros and restaurants.

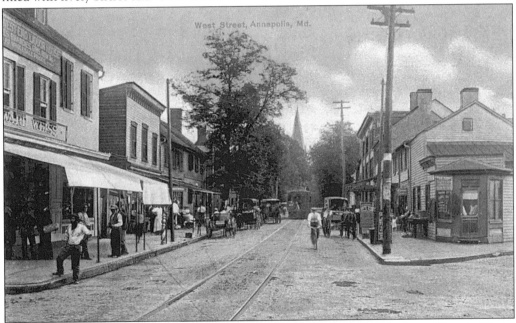

WEST STREET ACTIVITY. This is the lower end of West Street, approaching Church Circle. Although improved and heavy with automobile traffic, the road is no wider today. Very much in evidence are horse-drawn carriages and bicycles, the chief modes of transportation (other than feet) of the day, about 1908. An electric train can also be seen going toward St. Anne's Church on its way to Main Street and the docks.

GOVERNOR RITCHIE MEMORIAL ON GOVERNOR RITCHIE BOULEVARD. Albert C. Ritchie was Maryland's 49th governor and served four terms between 1920 and 1935. After an unsuccessful presidential bid, he was asked to be Franklin D. Roosevelt's running mate, but turned him down. This 1944 drawing shows the Naval Academy Chapel just to the right of the memorial, and on the far right, the State House dome and St. Anne's spire.

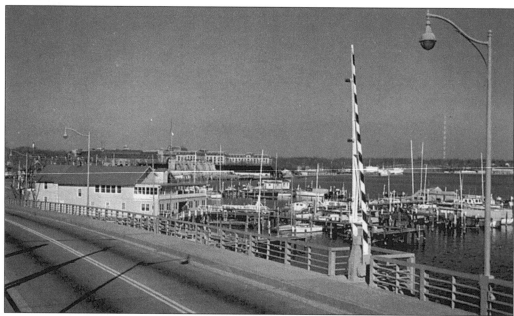

BRIDGE ACROSS SPA CREEK. Spa Creek serves Annapolis as the city's small boat harbor and yacht basin. The buildings of the Naval Academy are visible in the background.

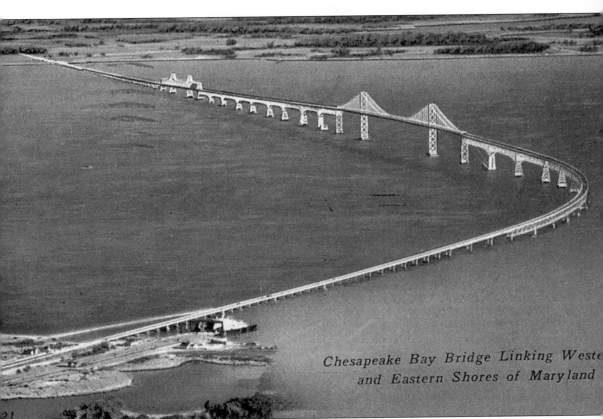

*Chesapeake Bay Bridge Linking Weste
and Eastern Shores of Maryland*

CHESAPEAKE BAY BRIDGE. This is the single span of the Chesapeake Bay Bridge as it appeared from 1952 to 1973, when a parallel bridge was added. It ran from Sandy Point on the west to Stevensville on the Eastern Shore and covered a distance of over 7.7 miles, 4.35 miles of it over water. It was built at a cost of over $45 million, and by 1961 was carrying a volume of 1.5 million cars per year. (By 1996, this figure had risen to an astonishing 20.5 million cars per year!) At the time of its completion, the bridge was the third longest bridge in the world. Prior to 1952 the only way to travel to the Eastern Shore was either by ferry boat or by driving north around the bay. This postcard was sent from Ocean City, Maryland on June 10, 1955 and tells the story of a nervous drive across the bridge in the rain.

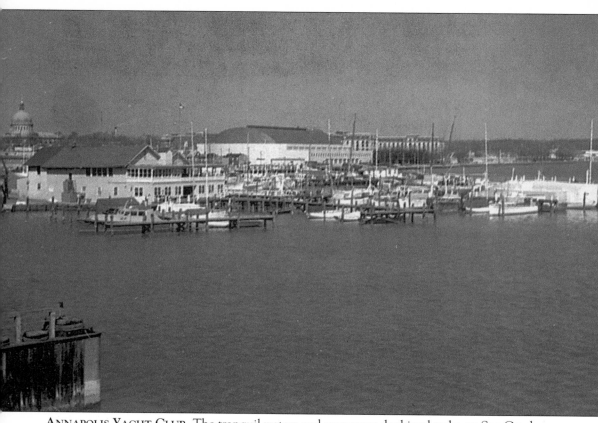

ANNAPOLIS YACHT CLUB. The tranquil waters and numerous docking berths on Spa Creek are the setting for the Annapolis Yacht Club. Annapolitan sailing enthusiasts are adamant that Annapolis is the true sailing capital of the world and point to the number of boats registered here to support this. Annapolis does, in fact, host the largest in-water sail and power boat shows in the world each year. No matter which side of the argument one supports, it is undeniable that Annapolis has an impressive and colorful seafaring past.

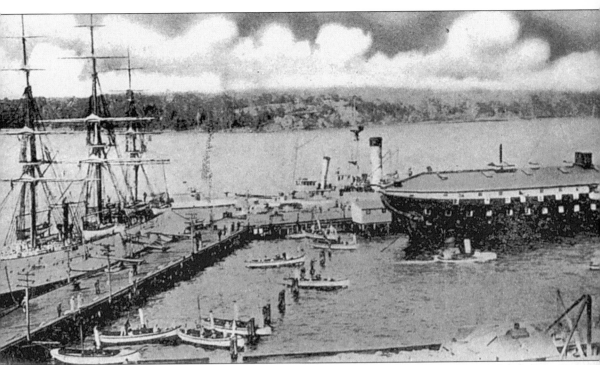

WHARF OF THE USS SANTEE. This pre-1906 view shows the USS *Santee* resting at the dock on the right. It was the "station ship" of the U.S. Naval Academy. Originally a fleet oiler, it saw wartime service as an escort carrier or "Jeep" and distinguished itself for highly successful anti-sub work. Late in World War II, it sustained damage from "kamikaze" attacks but stubbornly remained afloat. The ship on the left is the USS *Severn*, a sail training sloop used by midshipmen to make the transition from "landlubber" to sailor. In the shadow of the *Santee*, the smokestack of the CSS *Atlanta* can be seen. The *Atlanta* was originally the English blockade runner *Fingal*, commandeered by the Confederacy and converted to an Ironclad Ram. Union Monitors captured her in 1863.

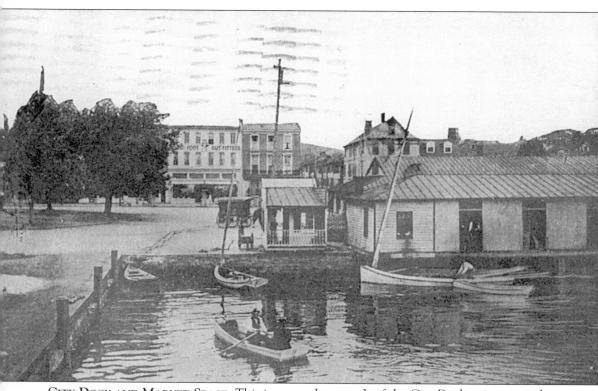

CITY DOCK AND MARKET SPACE. This is a rare photograph of the City Dock as it appeared in 1910. It quite likely appeared much this way in 1679 when Alex Haley's famous ancestor, Kunta Kinte, arrived here to be sold into slavery. Today, there is a small plaque on the dock commemorating the event. Just ahead is Market Space, an area dominated for many years by warehouses and bars. At the end of the street to the right would be Main Street leading up to Church Circle. The message on the back of the card is dated and postmarked November 21, 1910 and tells a friend in Islip, New York of a visit to "the State Buildings and Navay [*sic*] Acadmay [*sic*]." The visitor also "saw high cort [*sic*] in sesion [*sic*]."

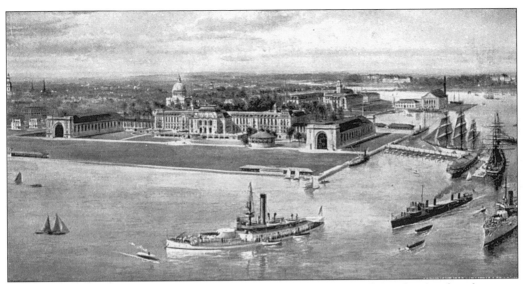

NAVAL ACADEMY AND HARBOR. This is a 1909 view of the Naval Academy only a few years after the main buildings were completed and only a year after the new chapel was dedicated. An interesting feature of this image is the variety of vessels, including pleasure craft, warships, and sailing sloops.

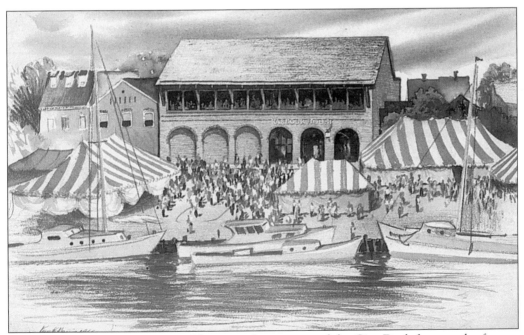

CITY DOCK IN A PARTY MOOD. This more festive view of the City Dock features the famous Harbour House Restaurant occupying a building once used as a warehouse. The locals call this area "Ego Alley," a reference to the number of expensive yachts from all over the world that tie up here.

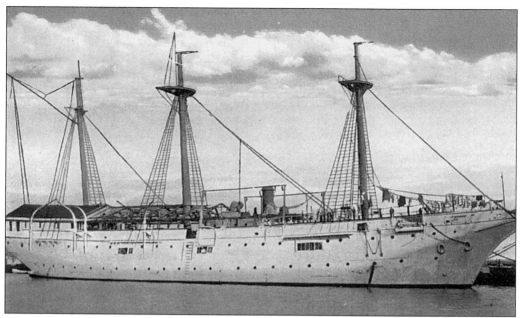

THE CUMBERLAND. This *c.* 1915 view of *The Cumberland* is yet one more example of the variety of ships that find their way to Annapolis docks. Note the "crows' nests" near the tops of the masts. Bits of clothing on lines strung across the bow of the ship tells us this must have been laundry day.

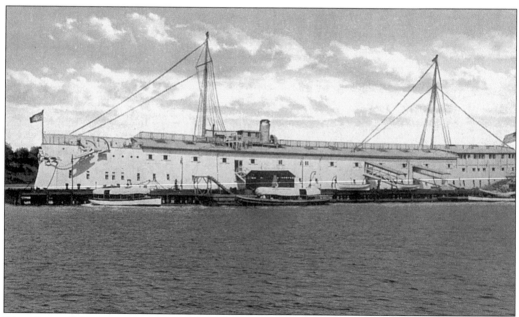

THE REINA MERCEDES. In 1912, this enormous Spanish cruiser and warship replaced the USS *Santee* as station ship for the U.S. Naval Academy. This view gives the ship the appearance of a floating house.

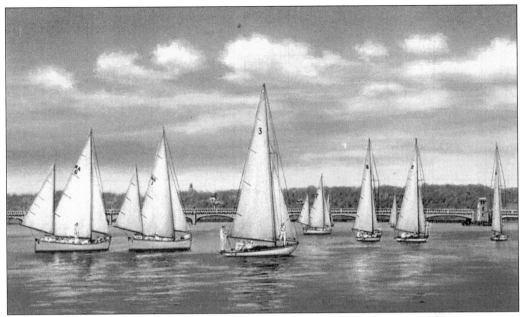

SAILBOAT DRILL. Here we return briefly to the Naval Academy to observe midshipmen gaining competency and confidence in their training as sailors. The Severn River Bridge can be seen in the background.

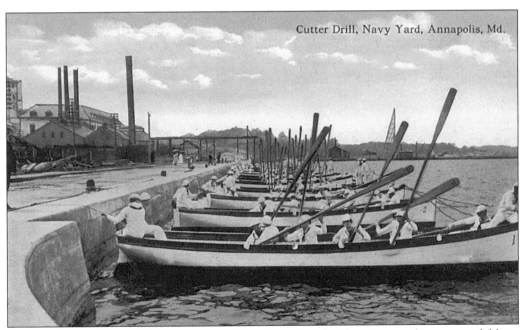

Cutter Drill, Navy Yard, Annapolis, Md.

CUTTER DRILL. The middies train on a wide variety of craft. There is no sail power available to them in this interesting picture, c. 1910. If you look closely, you will see two ladies strolling in the background, shyly observing from the other side of the pier.

SCHOONER AT REST. This is a portrait-type photograph of a schooner typical of the Chesapeake Bay region. Annapolis facilities support a vast number of both sport and commercial boats and ships. Through the mast rigging, the spire of St. Mary's on Church Circle can be observed.

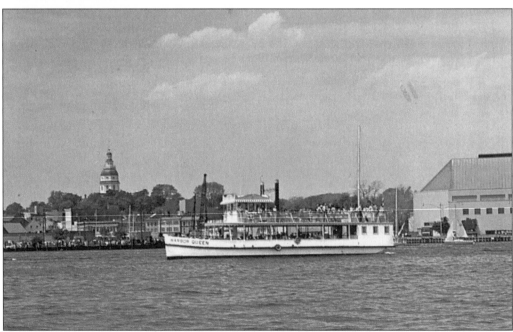

THE HARBOR QUEEN. Sightseeing boats are another type of craft seen frequently in these waters. This 75-foot twin diesel was built especially for Annapolis tours and is seen here leaving the pier at City Dock for a two-hour junket which will take in the harbor, the Naval Academy, the Severn River, and the Chesapeake Bay.

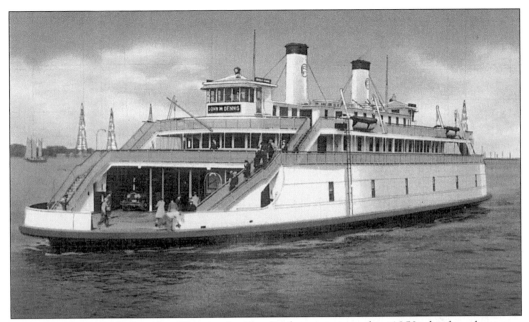

JOHN M. DENNIS. Before the Chesapeake Bay Bridge was opened in 1952, the ferry boat was the fastest way to traverse the Bay. The *John M. Dennis* operated between Annapolis and Claiborne, the northernmost point in Talbot County on the other side of Kent Island.

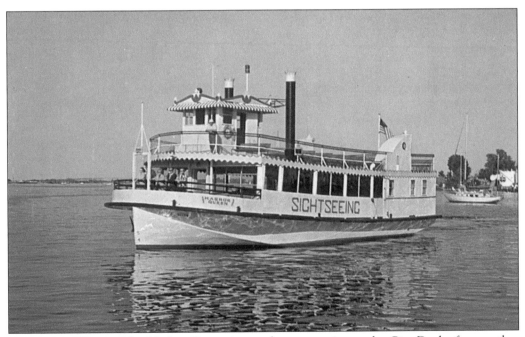

END OF THE TOUR. The Harbor Queen is seen here returning to the City Dock after another sightseeing cruise. The boat carries 300 passengers and the narrated tour is still the best, most interesting way to become familiar with the local waters.

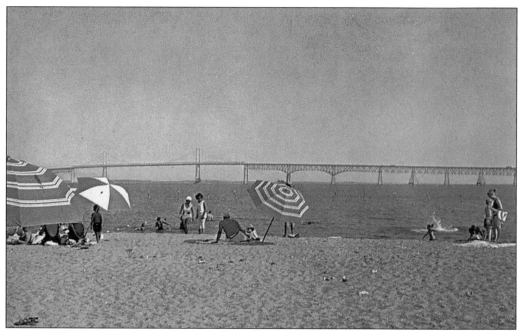

SANDY POINT STATE PARK. An alternative to making the two hour trip by car to the ocean, Sandy Point offers a sheltered marina, wide beaches, convenient facilities, and makes an excellent day trip for enjoying the sun and water. The earliest span of the Chesapeake Bay Bridge provides a splendid view.

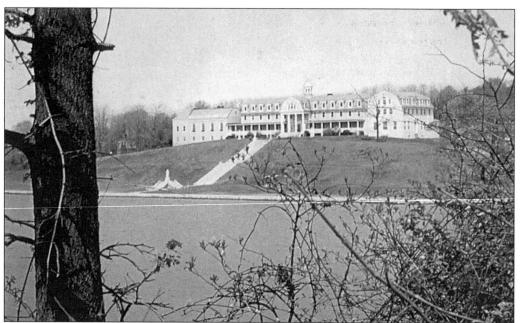

MANRESA-ON-SEVERN. This magnificent retreat house is maintained by the Jesuit Order of the Roman Catholic Church and has long been a part of the scenic Severn River. It is used for weekend retreats by a variety of local church and community groups, and its serene locale makes it an ideal choice for a weekend of meditation and relaxation.

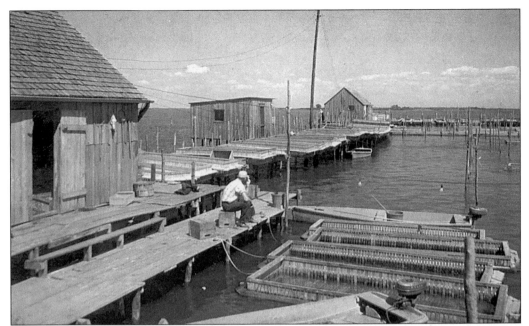

CRAB FLOATS AND SHANTY. A crabber relaxes after a day spent on the water harvesting the crabs that are provided to restaurants and stores all over the region. The Bay Crab Seasoning used to prepare this Maryland staple has contributed to making the Chesapeake Bay the greatest crabbing center in the world.

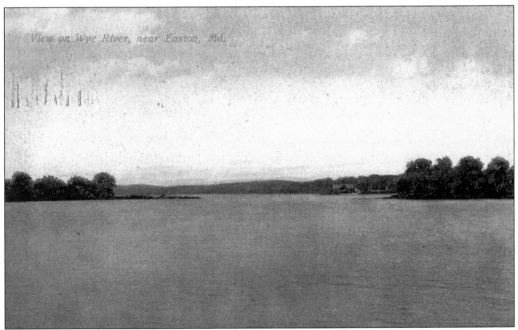

View on Wye River, near Easton, Md.

WYE RIVER SCENE. Little imagination is needed to understand why so many people prefer the tranquil quality of life on Maryland's Eastern Shore to the hustle and bustle of the big city. This photo of the Wye River near Easton, Maryland, was taken in 1908 but could have been taken yesterday.

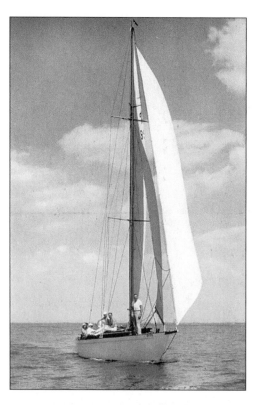

AMITIE. The owner of this fast, sleek-looking sailboat poses proudly for the camera in this photo taken from a companion craft. This is the *Amitie*, flagship of the Gibson Island Yacht Club, a short sail or drive from Annapolis.

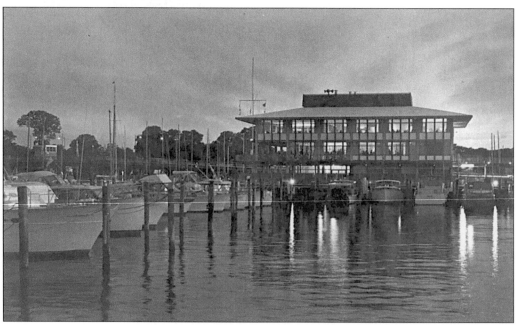

EVENING AT THE ANNAPOLIS YACHT CLUB. The club had its beginnings in 1886 and was incorporated as the Severn Boat Club in 1888. It was reorganized in 1938 and came into its fullness as the Annapolis Yacht Club. In this scene, members spend an evening in the well-appointed clubhouse swapping stories of the day's adventures on the Bay and its tributaries.

Five
Small Town,
Maryland

In the wake of colonial expansion and exploration, a number of small towns rose up between Annapolis and Washington and down into Southern Maryland. There were a variety of reasons for this growth. Some individuals were given grants of land from the government and towns were established in their name. Other locations presented natural vacation and resort topography since they were located on attractive beaches or quiet lakes. Others sprung up out of necessity as trading centers or simple way stations to sustain the traveler on the way to his destination. Many of these towns grew into major cities and became notable as centers for industry, business, or perhaps health care. Others faded away or simply settled into a relaxed routine that perhaps continues today. St. Mary's City, for example, lost its status as capital of the State of Maryland but lost none of its dignity. It survives today and its residents are proud of their town for what it was and for its part in their lives in the present context. All of these towns have their story and once again, we turn to the postcards of different eras to become acquainted with them.

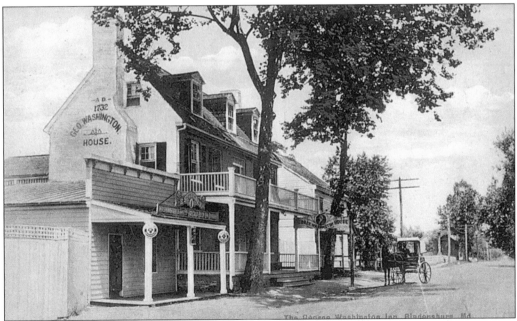

THE GEORGE WASHINGTON INN. The printing on the chimney indicates that this bed and breakfast has been around since 1732, and this rare photograph tells us it was still there in 1910 in the town of Bladensburg, just outside of Washington, D.C. The paved road and utility pole warns that it would soon be absorbed by faster modes of travel than the horse and buggy parked out front.

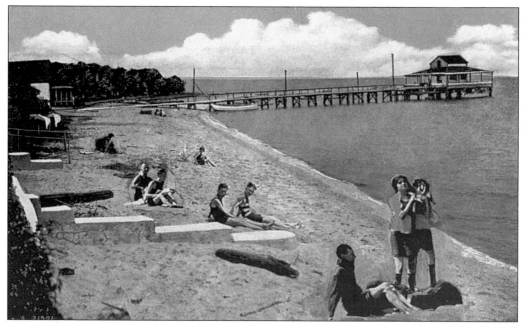

NORTH BEACH. North Beach and Chesapeake Beach rose up along the Bay almost due south of Annapolis in Calvert County. This early twentieth-century photograph shows the relatively modest attire of the day's beach-goer compared to the sun worshippers of today.

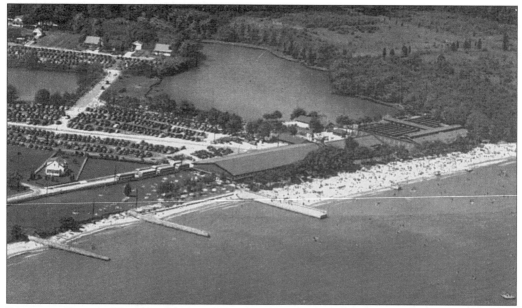

BEVERLEY BEACH. This aerial view of Beverley Beach, another Bay resort just 11 miles from Annapolis, shows the popularity of such places as evidenced by the crowded parking lots despite the dirt road access. Although through the years the shoreline has been plagued by problems of beach reclamation (not to mention the annoying sea nettles), they remain a popular alternative to the far away ocean beaches.

CAMP MEADE DAYS. This photo postcard of two brothers-in-arms stationed at Camp Meade (now Fort Meade) was taken at the Vincent Mitchell Studio in Baltimore. The studio and the soldiers are long gone, but the doughboys' image leaves evidence that they passed this way.

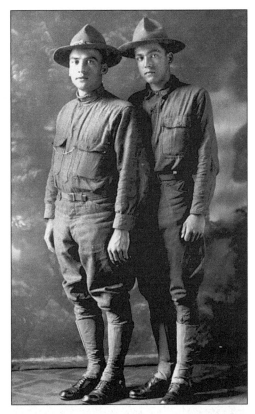

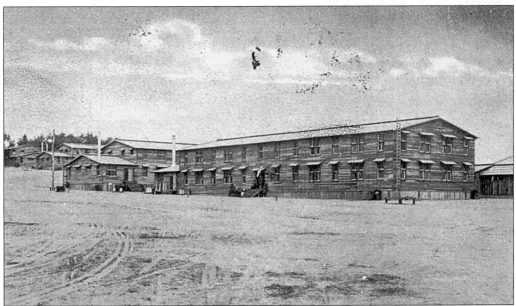

BARRACKS OF THE 23RD ENGINEERS. The sameness of barracks at army posts all over is shown dramatically in this stark Camp Meade image, the subject of a 1918 postcard sent to a Harry German of Lehighton, Pennsylvania. The writer sounded happy to be leaving as he wrote "Well Harry I think we will be on the way before long . . ."

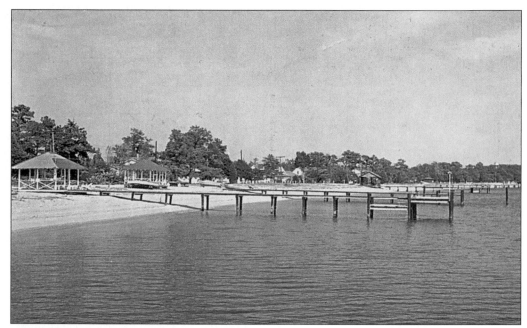

PINEY POINT. This beautiful spot is in St. Mary's County in Southern Maryland right on the Potomac River across from Virginia. Pictured is just one of a number of private piers along this wonderful shoreline.

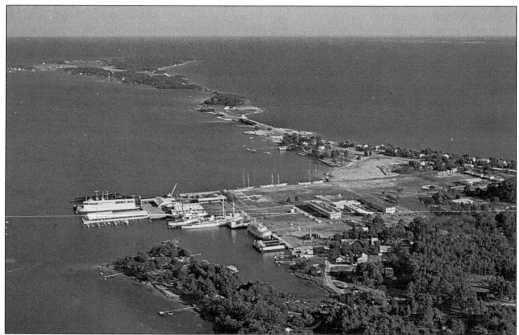

HARRY LUNDEBERG SCHOOL. Located at Piney Point, the Harry Lundeberg School is the largest training facility for merchant seamen in the country. The school is sponsored by the Seafarers International Union. Ideally situated, the dock can receive several sizable ships. On the right is the Potomac River and in the distance is St. George Island.

BERWYN, MARYLAND. This tiny city (also known as Berwyn Heights) survives today as a small residential town located just 7 miles outside of Washington, D.C. This particular photo card is really an advertisement for the Del Haven White House Cottages, a collection of brick cottages, and entices the traveler with promises of steam heat, Beautyrest mattresses, and even a radio in selected units (extra of course).

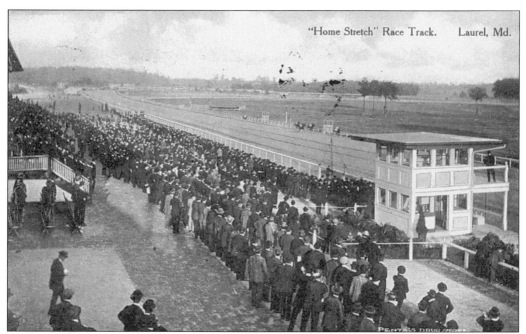

"Home Stretch" Race Track, Laurel, Maryland. Maryland is well known internationally as horse country for such places as the Laurel Race Track, the Woodward Stables in Bowie (that produced three Triple Crown winners), and Pimlico in Baltimore (the second jewel in the Triple Crown.) The message on the back of this 1916 photo card expresses wonder that some friends "have made 1100 miles in seven days."

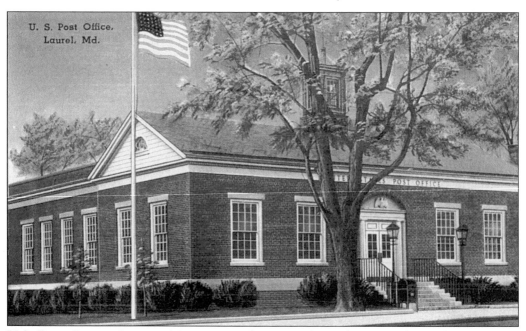

U.S. Post Office, Laurel, Maryland. The town of Laurel is a popular residential choice not only for horse racing fans, but also because of its central location and easy access to major arteries leading to Washington, D.C., Baltimore, Fort Meade, and Annapolis.

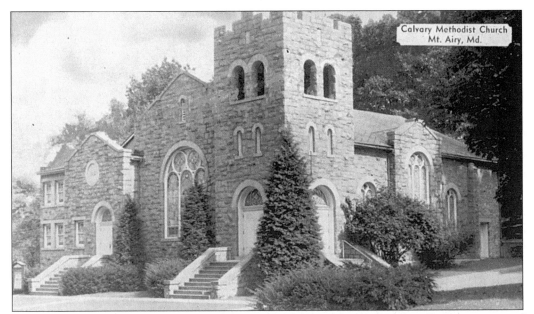

CALVARY METHODIST CHURCH, MT. AIRY, MARYLAND. Mt. Airy is another in a group of residential towns that sprang up outside the nation's capital, in part, as summer cottages so that many of the city's more well-to-do residents could escape the heat of the city. Many of the homes in the area are quite stately, even by today's standards.

"RIDGECREST." In the 1930s, Mrs. E. C. Dornheim of Mt. Airy made her spacious home available as a vacation residence for ladies of good repute. On this photographic postcard, postmarked July 23, 1937, a lady named Emma expresses dismay to her dear friend Bertha that she had forgotten her birthday card and apologetically offers her "best wishes."

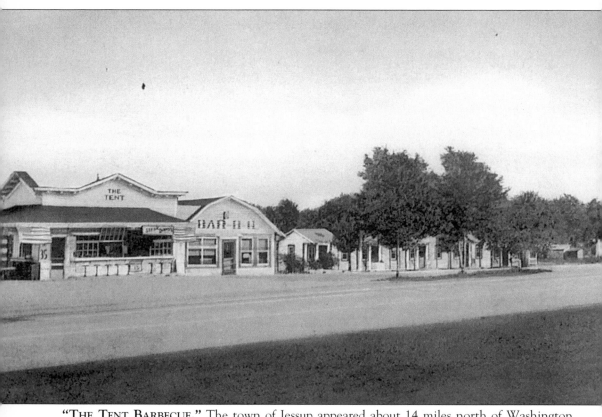

"The Tent Barbecue." The town of Jessup appeared about 14 miles north of Washington and provided refuge to travelers making their way northward up Route 1 to towns like Baltimore, Philadelphia, and New York. The Tent Barbecue might be considered a bit primitive and ramshackle today, but it served up a nice steak dinner and tasty sandwiches and bragged that its cabins were clean, furnished, and had running water. Reservations can be made by dialing "Waterloo 273-W3." Today, Jessup is home to many of Maryland's less trustworthy and more notorious citizens possessing both a maximum-security prison and a less secure pre-release camp.

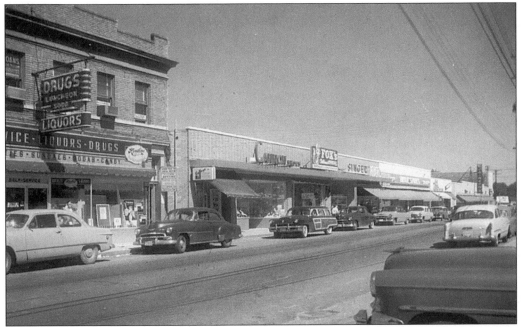

GLEN BURNIE, MARYLAND. This stretch of Baltimore-Annapolis (B&A) Boulevard in Glen Burnie was considered a modern shopping area in the mid-1950s, complete with a Rexall and a "five and dime." Note that the electric rail tracks are still present. Today, Glen Burnie has a firm grasp on the "mall" concept, but B&A Boulevard still looks much the same.

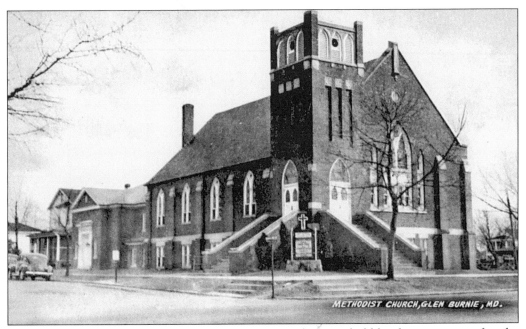

METHODIST CHURCH, GLEN BURNIE, MARYLAND. This grand old brick structure typifies the churches that were built in the middle of residential neighborhoods, making them both literally and figuratively a part of the community they served. The barren look of this winter scene is given warmth by the reassuring presence of this solid edifice.

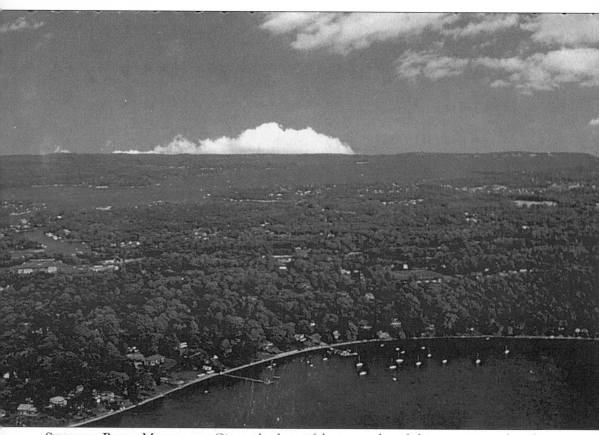

SEVERNA PARK, MARYLAND. Given the beautiful topography of this area situated midway between Baltimore and Annapolis, it was natural that a community of people in love with the water and the land would be established here. The Severn River is at the bottom of the photograph and at the top is the Magothy River. Today, the city of Severna Park is made up largely of professional people with beautiful homes along the shoreline and private docks.

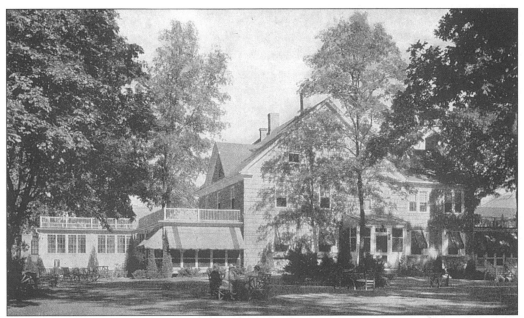

OLNEY INN. Olney is a town 12 miles outside of Washington that has consciously avoided catching up with time too quickly. It's Quaker roots are evident in winding roads approaching the town and in old, established, well-kept neighborhoods. Warily accepting the need for more modern shopping conveniences, larger stores have been carefully kept at the edge of town.

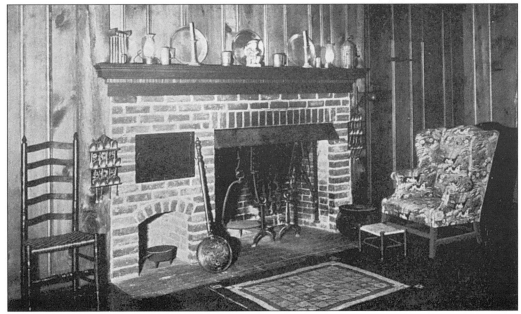

ENTRANCE HALL. The meals at the Olney Inn are the chief attraction of this quaint city. The entrance hall mimics the "American Kitchen" in the Metropolitan Museum of Art. Its reputation for well-prepared repasts and old cooking traditions make the restaurant worth the trip from anywhere in the area.

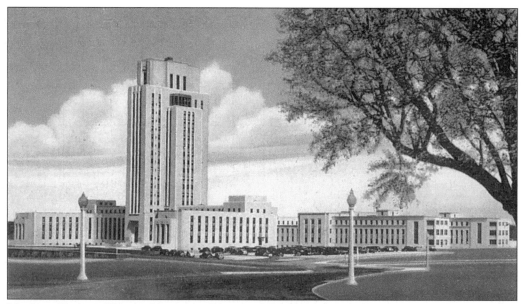

UNITED STATES NAVAL MEDICAL CENTER (USNMC). Not all towns growing out of the colonial period were destined to remain small. Bethesda is a prime example of this. Right in the shadow of Washington, it has almost assumed the role of healer for this area of Maryland. The facilities of the USNMC are said to rival even those of the medical center in Vienna.

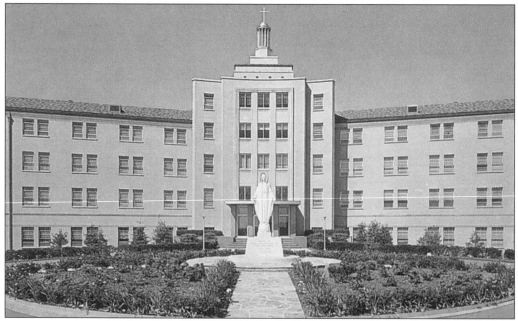

MERCY GENERALATE. Reinforcing the impression of Bethesda as a city of healing is this representation of the Sisters of Mercy. This fine order of dedicated religious women founded by Catherine McCauley is committed to working with the poor all over the world to tend to their physical and spiritual welfare.

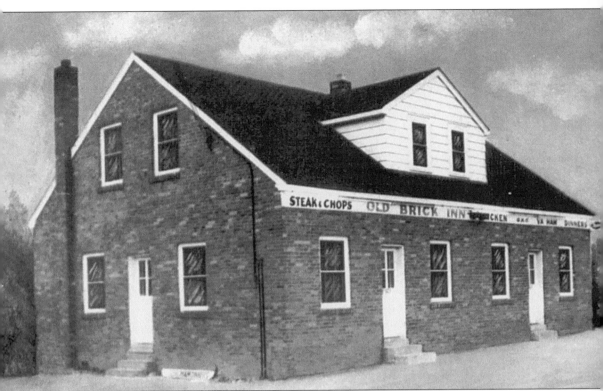

OLD BRICK INN. Even though Upper Marlboro, Maryland has long been the seat of government for Prince George's County, it has always seemed unwilling to let go of its country origins. Outside of a downtown section of several blocks, consisting of a courthouse with the requisite number of lawyers' offices and administration buildings, the surrounding area has remained largely agrarian, especially with a large tobacco crop. It is only in recent years that any serious attempts have been made to develop the area's residential communities and shopping. The Old Brick Inn pictured typifies the pace of life in the Upper Marlboro area. If you'd like reservations, just pick up the phone and dial Marlboro 9879.

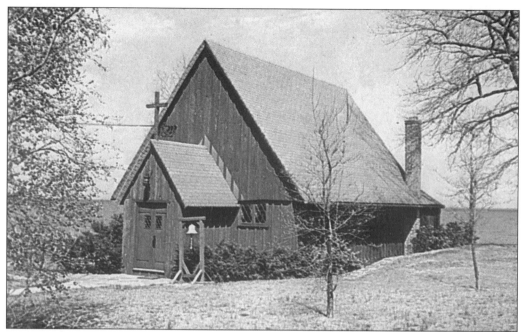

ST. CHRISTOPHER'S BY-THE-SEA. What more enduring symbol of the seafaring way of life is there than the solitary chapel by the sea? You can almost hear the bell peal at this tiny church on the shore of Gibson Island announcing the arrival of the long-awaited sailor; or perhaps it tolls mournfully at the loss of the seafarer.

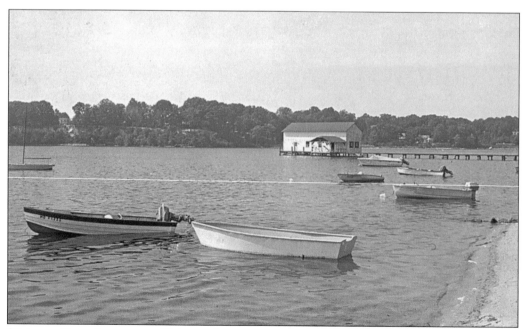

SEVERNA PARK SHORELINE. This is a closer view of the Severna Park coastal waters in a picture taken across the cove at Round Bay. These waters are ideal for swimming and boating.

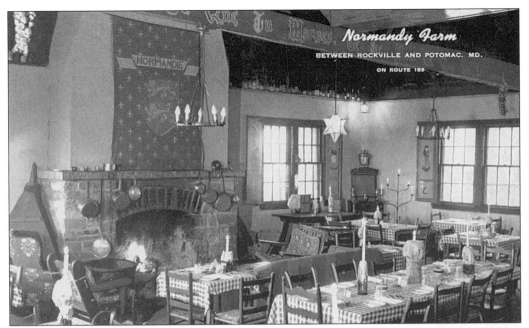

NORMANDY INN. This photo view of a French Provincial restaurant was taken in the 1940s in a predominately rural area between Rockville and Potomac, Maryland. The area has been highly developed since then and today is a busy network of highways, shopping, and housing.

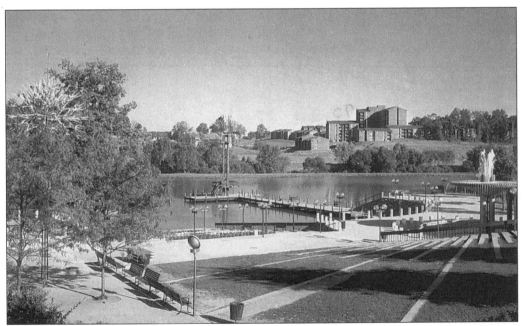

COLUMBIA, MARYLAND. A more recent city, Columbia sits on Route 29 between Baltimore and Washington and typifies the relatively new concept of a "planned" community. In Columbia, you can find anything from subsidized housing to estate homes and everything in between. This is a view of Lake Kittamaqundi and an apartment complex in one of the city's several villages.

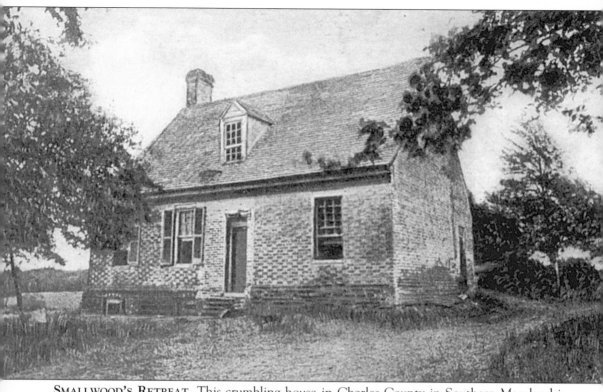

SMALLWOOD'S RETREAT. This crumbling house in Charles County in Southern Maryland is the home where General William Smallwood lived and died. Smallwood was a famous Revolutionary War hero in the area, having led Maryland volunteers in battle. He later served as governor of the state.

Six

GATEWAY TO THE
EASTERN SHORE

Annapolis truly is the gateway to Maryland's Eastern Shore. The other side of the Chesapeake Bay has its own lifestyle, its own customs, even, some would say, its own language. For example, it's common to walk into a diner and hear the waitress say, "Wuttelyahav, hon?" or another popular idiom is "M R Ducks" as in response to the question "Are those geese?" "No, hon, m r ducks!" Those who were not born there either retired to the shore, or maybe escaped, there. Whatever the category, the inhabitants jealously guard their customs and way of life, and some even look upon their little peninsula as a separate state. (They probably would have voted to secede from the Union and the Confederacy.) But, from quiet college towns to bustling fishing villages, each little area is a delight to visit, so let's sort through some more cards and drop in on a few.

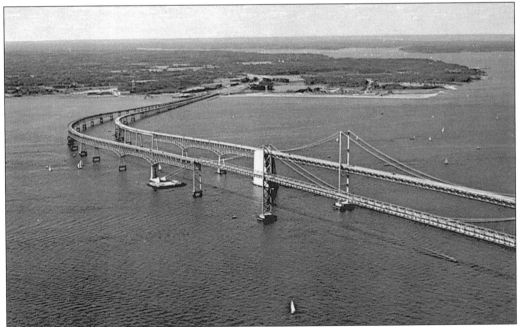

TWIN SPANS. In 1952, when the first span was completed, the Chesapeake Bay Bridge handled 1.1 million cars. In 1973, construction of a second span was finished to handle the 20.5 million cars that would cross over it in 1996. The increase in population and popularity of the Eastern Shore as a tourist attraction and sportsman's paradise combined to make more lanes necessary. The ferry service of old would be a bit strained without the bridge.

OLD TRINITY EPISCOPAL CHURCH. It's worth the trip to the shore just to visit the old churches. This historic church is believed to be the oldest church in America now in active use. It is located in Dorchester County 1 mile west of Church Creek and to the southwest of Cambridge.

OLD TRINITY CHURCH NAVE. Ducking into the interior of an old church in Maryland is like stepping through a time portal. This is where you truly experience the feel of colonial times. Interesting features of this place of worship are the gallery at the rear and the three-decker pulpit.

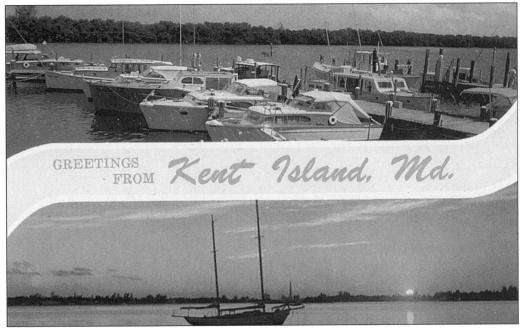

KENT ISLAND. Kent Island is the first "stepping stone" between the Chesapeake Bay and the Eastern Shore. The bridge takes you briefly by the town of Stevensville, then across the most narrow portion of the Eastern Bay, and then you are solidly in another land.

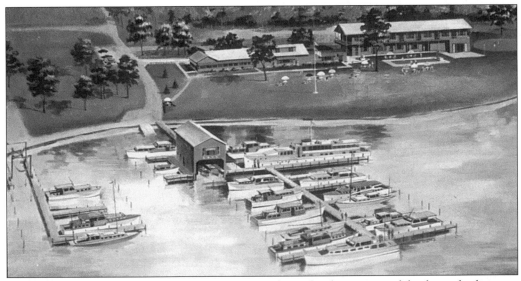

CHESTERTOWN YACHT CLUB. Chestertown is acclaimed to have some of the finest facilities on the East Coast for hunting upland game and wild fowl. It is located on the Chester River in the Upper Chesapeake. The illustration on this card shows the Great Oak Lodge, one of the tees on a nine-hole golf course, and a fine marina.

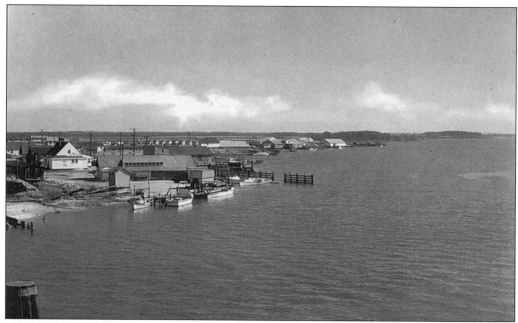

KENT NARROWS. This is a waterfront scene typical of many found on the Eastern Shore with oyster packing houses prominent. This section of the Chester River is still considered one of the leading sport and commercial fishing ports in the East.

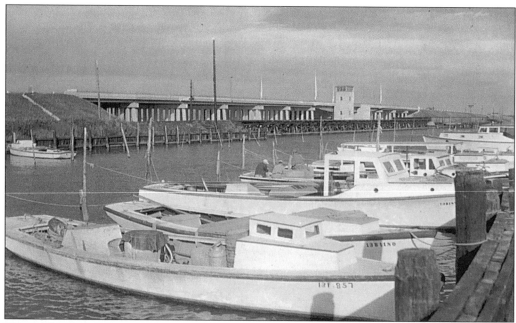

KENT NARROWS BRIDGE. This aging, but still sturdy bridge connects Kent Island with the "mainland" Eastern Shore. "Narrows" refers to the narrowest part of the body of water known as East Bay.

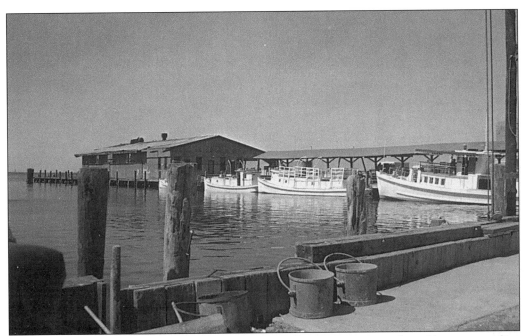

DOCK AT CRISFIELD HARBOR. The boats at this dock are passenger and mail boats, providing service to Smith and Tangier Islands, the only way to reach these towns. Crisfield is famous for crabs, oysters, and Diamond Back Terrapin nurseries The terrapin is the mascot for the University of Maryland, and the school's newspaper is called the *Diamondback*.

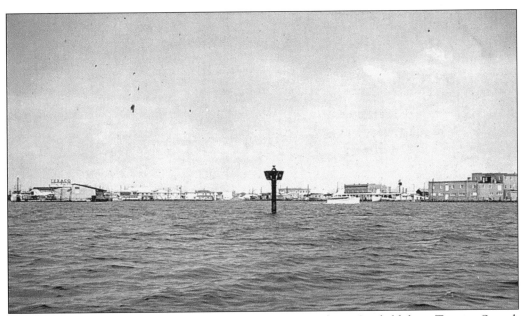

CRISFIELD WATERFRONT. This is the view when approaching Crisfield from Tangier Sound. The entrance to Somers Cove Marina is just to the left of the channel marker.

NEW CHESTER RIVER BRIDGE, CHESTERTOWN, MD.

CHESTER RIVER BRIDGE. Chestertown was the original site of Baltimore. It turned out to be too small a port to serve the needs of this important city, so it was moved to its present location. The writer of this old photo postcard talks of crossing the bridge at night (notice the lanterns) and enduring 10-degree weather.

WASHINGTON COLLEGE. Chestertown is a college town too. George Washington not only slept here, but gave the college his name on its founding in 1782. While serving on the school's board of visitors and governors, he received his doctor of law degree in 1789.

110

CENTERVILLE EPISCOPAL CHURCH.
Before the Maryland colony was allowed to go on a standard of paper currency, the two main exchanges were coins and tobacco. Coins were rare, and this Episcopal Church was built in the early 1700s at a cost of 15,000 pounds of tobacco.

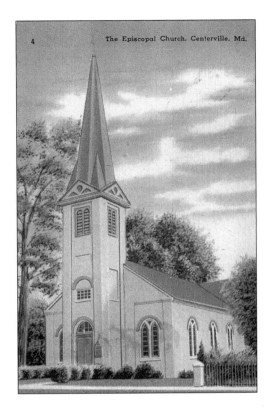

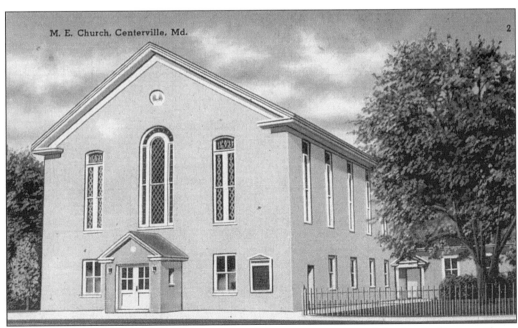

M.E. CHURCH, CENTERVILLE, MARYLAND. Like many towns on Maryland's Eastern Shore, Centerville is characterized by a genuine small town feel with tree-lined avenues, peaceful churches, and wonderful bed and breakfasts.

MAIN STREET, LOOKING EAST. Salisbury is one of the largest cities on the Eastern Shore and certainly one of the busiest, being the county seat of Wicomico County. This 1950s scene along Main Street shows both the old and new courthouses and the post office building.

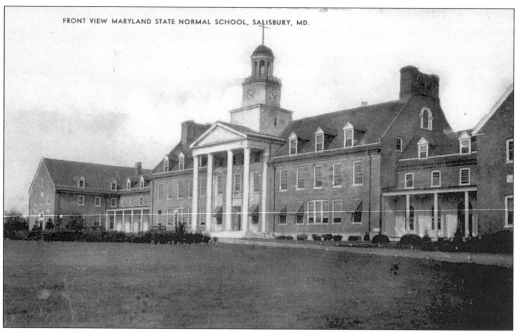

FRONT VIEW MARYLAND STATE NORMAL SCHOOL, SALISBURY, MD.

MARYLAND STATE NORMAL SCHOOL. This old photo card of the Normal School (a rather antiquated term) is not postmarked but probably dates back to the 1920s. Salisbury also had what was known as a "State Teacher's College," but this, too, has been updated and is now called Salisbury State University.

TOO BUSY TO WRITE IN CAMBRIDGE. This card is of a generic type, popular *c.* 1920, that was widely distributed in a region with the particular city stamped into a blank space. The sender of this card really did live in Cambridge and expresses his delight that a Detroit friend is recovering from an illness.

MUNICIPAL BOAT BASIN, CAMBRIDGE, MARYLAND. As is the case with many Eastern Shore communities, Cambridge's location on the south side of the Choptank River makes it a desirable location for boaters and fishermen. It was also the birthplace of Harriet Tubman, legendary heroine of the underground railroad. On September 5, 1941, Pa writes the following to a Mrs. James Martin in Lancaster, Ohio: "All Well Pa." Pa was a man of few words.

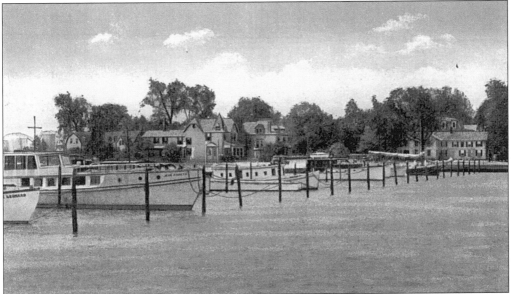

OLD WYE MILL. The Old Wye Mill is one of several notable places to see in Wye Mills, Maryland. This particular mill can be traced back to 1664 and produced flour for Washington's troops during that infamous winter at Valley Forge. The mill is restored and is in good operating condition.

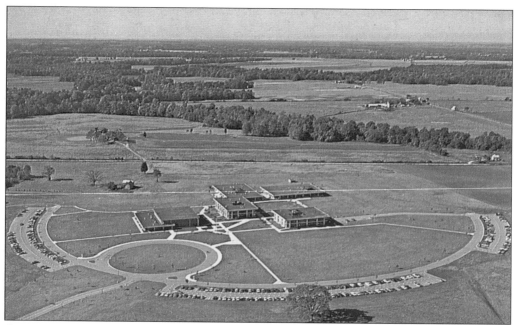

CHESAPEAKE COLLEGE. This aerial view of Chesapeake College presents an interesting panorama of a relatively unsullied countryside. The two-year regional school serves students in four surrounding counties.

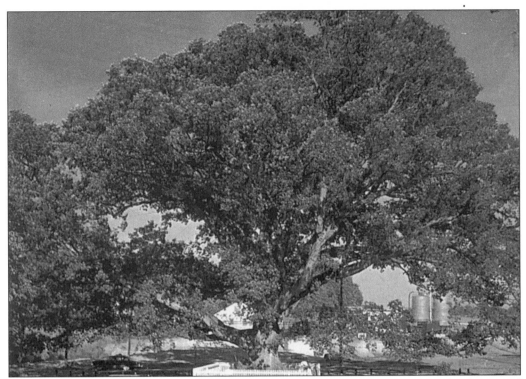

THE WYE OAK. This and the Liberty Tree are the two most famous trees in Maryland. Located near the town of Wye Mills, this tree is estimated to be well over 400 years old. It is also believed to be the largest white oak in the United States and is the official state tree of Maryland.

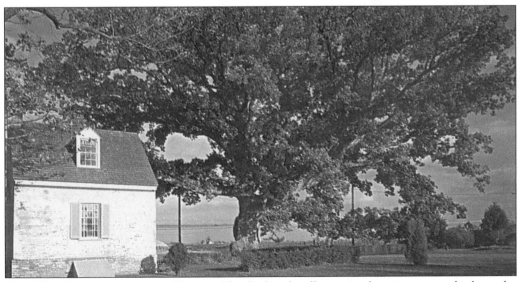

THE WYE OAK AND SCHOOL HOUSE. The little schoolhouse in this picture was built in the early 1700s and underwent a major restoration sponsored by the Queen Anne's Garden Club in 1952.

PRINCESS ANNE COUNTY COURT HOUSE. Like many towns in this part of Maryland, Princess Anne was born of the Eastern Shore's "Golden Age" in the eighteenth century, when towns that produced primarily tobacco crops took advantage of newly opened trade opportunities with Europe and became major centers of commerce. Princess Anne rests in Somerset County at a narrow point near the head of the Manokin River called the "wading place."

PRINCESS ANNE ELEMENTARY SCHOOL, PRINCESS ANNE, MD.

PRINCESS ANNE ELEMENTARY SCHOOL. Princess Anne (named after the daughter of King George II) has many fine schools, the gem of which is the University of Maryland Eastern Shore. The photo image on this card can be traced back to the 1940s.

116

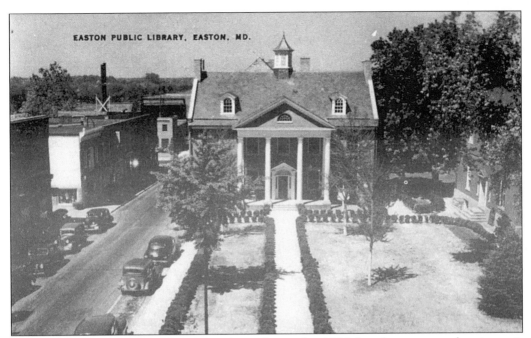

EASTON PUBLIC LIBRARY. The postmark on this card is 1956, but the autos say the picture is much older. Easton was originally named "Talbot Court House" and is, in fact, the county seat of Talbot County. It is best known as "The Colonial Capital of the Eastern Shore" and has been called the "8th best small town in America."

FRIENDS OLD MEETING HOUSE. Also known as the "Third Haven Meeting House," this structure is believed to be the oldest framed religious meeting building in America. It took two years to build because the timbers had to be hewed with a broadaxe and tool selection was a bit limited in 1682. The house was faithfully restored in 1990, and Sunday morning meetings have resumed.

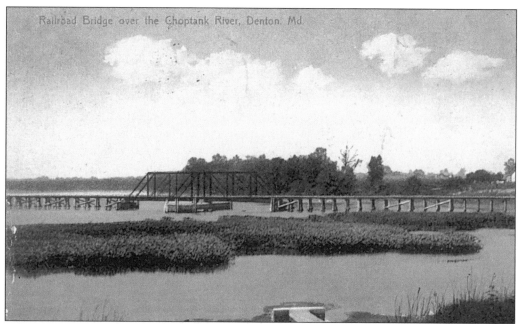

RAILROAD BRIDGE OVER THE CHOPTANK RIVER, DENTON, MARYLAND. In much the same way that the town of Princess Anne profited from the "golden age," so did Denton enjoy a measure of prosperity in the eighteenth century. Later on, its accessibility by both rail and sea made it a successful center of commerce on the Eastern Shore.

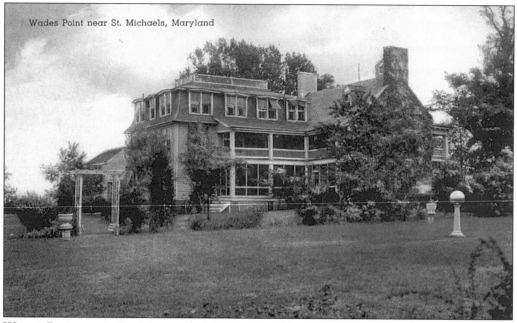

WADES POINT NEAR ST. MICHAELS, MARYLAND. This nineteenth-century plantation home is called Wades Point Inn today and operates as a bed and breakfast. St. Michaels is also the home of the Chesapeake Bay Maritime Museum, a necessary stop on the Eastern Shore for enthusiasts and students of the sea.

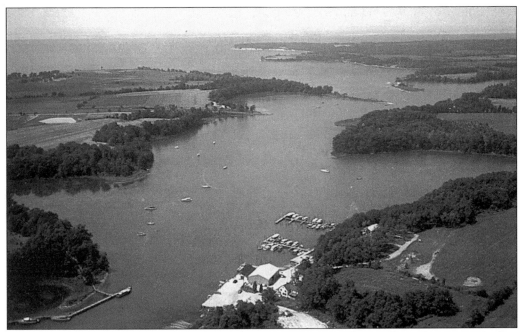

WORTON CREEK. Worton Creek, located in Kent County above Chestertown, is another popular destination for boaters and vacationers. Its numerous natural inlets make for excellent docks and marinas.

GANEY'S WHARF. Caroline County owns this popular recreational facility. It sits on the Choptank River about 7 miles southwest of Denton.

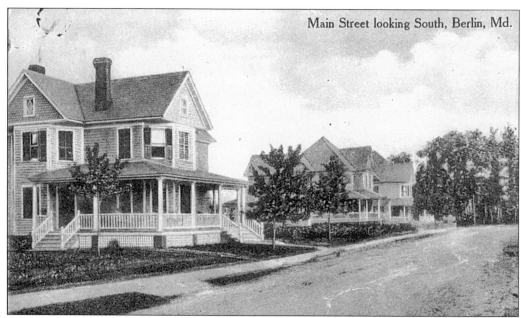

Main Street looking South, Berlin, Md.

MAIN STREET, BERLIN, MARYLAND. This street was originally just a footpath connecting the Assateague Indians with the nearby Pocomoke tribe. In colonial times, it evolved into the well-known Philadelphia Post Road, the main travel route from this part of the Eastern Shore heading north and west to the major commerce centers.

BERLIN VOLUNTEER FIRE DEPARTMENT. Providing a contrast to less secure days, the fire department gives a level of comfort unknown to the earlier settlers. It has been surmised that the town's name is actually a contraction of "Burleigh Inn," a tavern that stood at the crossroads of the Philadelphia Post and Sinepuxent Roads.

STEPHEN DECATUR JUNIOR-SENIOR HIGH SCHOOL. Serving the needs of students in the northern part of Worcester County, this modern consolidated school is situated between Berlin and Ocean City.

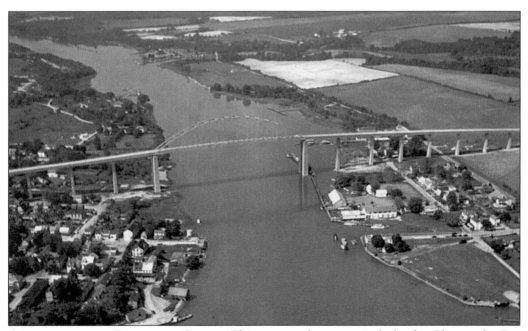

CHESAPEAKE AND DELAWARE CANAL. This man-made waterway links the Chesapeake Bay with the Delaware Bay, passing through Chesapeake City in Cecil County, the northernmost county on the Eastern Shore. This is a crucial artery for overseas and coastal shipping since it is the shortest route between Baltimore and the Atlantic Ocean.

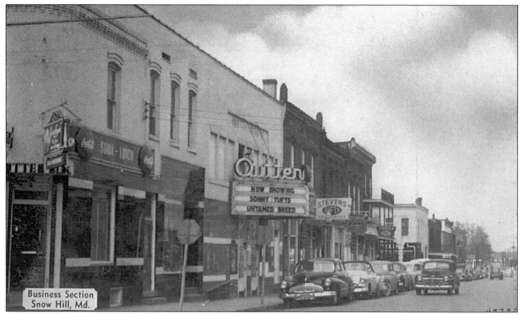

BUSINESS SECTION, SNOW HILL, MARYLAND. Seen here is Washington Street as it appeared in the 1950s. The original downtown section of the city was destroyed by fire in 1893. Originally incorporated in 1686, Snow Hill is the county seat of Worcester County, sometimes called the Lower Shore.

SHAD LANDING STATE PARK. This park faces the Pocomoke River and offers much more than shad for the fisherman. The river also carries a fine assortment of perch, catfish, pickerel, herring, and large mouth bass.

FIRST BAPTIST CHURCH OF POCOMOKE CITY. This perfectly restored Market Street Church is one of a number of fine houses of worship that characterize small town life on the shore. Pocomoke, originally known as Stevens Ferry, is the industrial center of Worcester County just a few miles north of the Virginia border.

View along Pocomoke River, Pocomoke City, Md. P6

J. Dawson Clarke, Photographer

VIEW ALONG THE POCOMOKE RIVER. One of the most scenic of Maryland waterways, the Pocomoke River, with its surrounding wetlands, is home to at least 127 species of birds and waterfowl, including the bald eagle. At one time, furs, whiskey, and tobacco were transported along these waters to major ports and distribution centers.

GREETINGS FROM

Assateague Island

ASSATEAGUE ISLAND. Named after the Assateague Indian tribe, the island stands as the last barrier before the Atlantic Ocean. Besides camping, its major attraction is a herd of wild ponies.

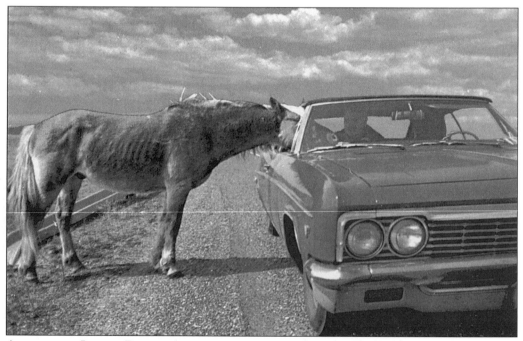

ASSATEAGUE ISLAND PONIES. A common misconception is that these ponies are domesticated, gentle creatures that are eager to be petted. The truth is that they have been fed so much over the years by well-meaning tourists that they have actually become dangerous and can turn quite demanding and aggressive if they suspect food is present.

WHITE CRYSTAL BEACH, EARLESVILLE, MARYLAND. Located in southern Cecil County, Earlesville has a 190-acre wildlife parcel set aside for game animals. Here, beavers co-exist with wood ducks and large beaver dams can be seen. The town even brags a condominium style RV resort. Another attraction is St. Stephen's Episcopal Church, which is on the National Register of Historic Places.

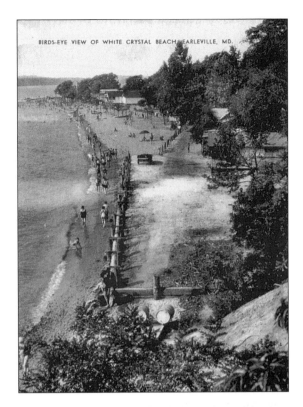

BIRDS-EYE VIEW OF WHITE CRYSTAL BEACH, EARLEVILLE, MD.

CHESAPEAKE CITY MARINA SCENE. This photo card dates back to about 1930 and shows a common theme of the area's activities. The city came to prominence chiefly as a result of the Chesapeake and Delaware Canal, which significantly reduced shipping time from the Atlantic to inland locations along the Chesapeake Bay.

COLONIAL HOTEL, OCEAN CITY, MARYLAND. This photo image of the Colonial Hotel in Ocean City was made shortly before the 1933 hurricane created a natural harbor and gave birth to a commercial fishing center as well as a growing resort. In 1869, there was only a solitary one-story inn to serve the entire city. Nearby Berlin was the main tourist destination at the time.

RAPID TRANSIT, OCEAN CITY, MARYLAND. Even in 1916, travel was probably a little more convenient. The message on the back is from Florence to her friend Louisa in Chardon, Ohio and states that she and Elgin "came over here yesterday on the 12:05 train" and that they "are going in bathing sometime today."

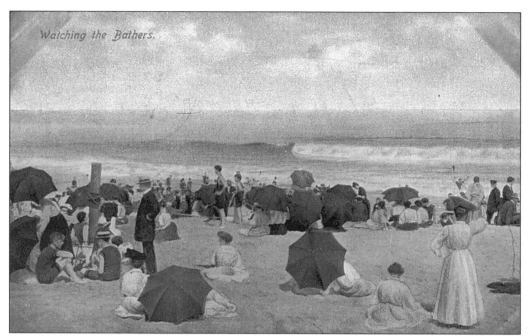

WATCHING THE BATHERS. On August 29, 1907, Carrie writes "The bathing is fine but the wave [*sic*] are very strong there is a fine crowd down here." It's difficult to imagine Carrie having a fine time in the surf if she was dressed like these other ladies. Small wonder they were so pale back then.

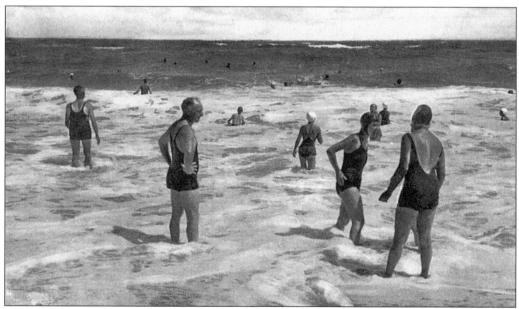

IN THE SURF, OCEAN CITY, MARYLAND. It appears that by the 1930s the standards for acceptable beach attire had relaxed quite a lot. The vacationers in this photo are enjoying the water, rather than just staring at it.

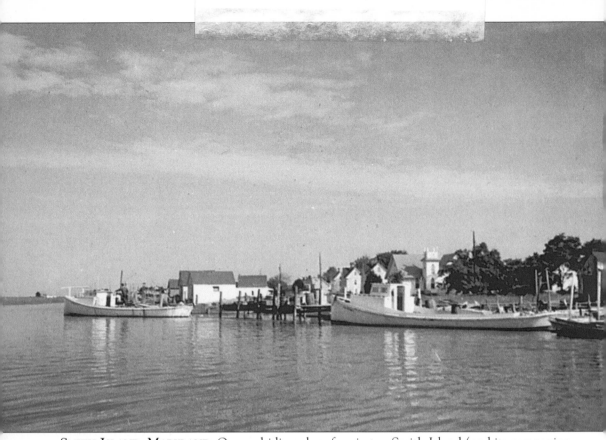

SMITH ISLAND, MARYLAND. Once a hiding place for pirates, Smith Island (and its companion Tangier Island) is accessible only by boat or helicopter. It is the only inhabited off-shore island in the Chesapeake Bay. The photograph is of Rhodes Point (once called Rogues Point), one of only three communities on the island. The other two are Ewell and Tylerton and are connected by the island's only road. The primary livelihood for the islanders (total population 450) is the harvesting of Chesapeake Bay Blue Crabs. The residents and scientists have been fighting a losing battle with Mother Nature for a very long time. The island is slowly disappearing due to global warming and erosion and the best minds say it will be uninhabitable in another 20 years. (They said that 20 years ago, too.)